LOS ANGELES
THEN & NOW

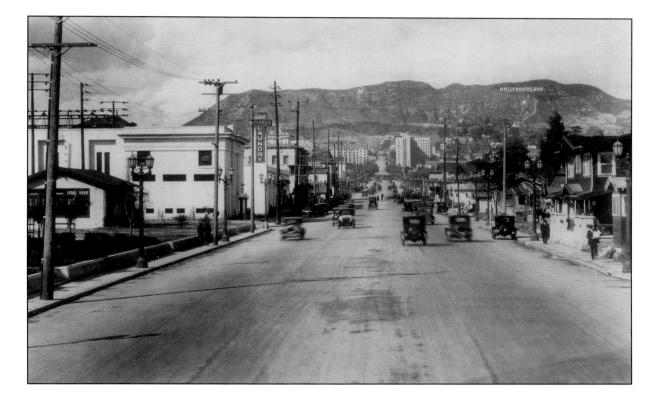

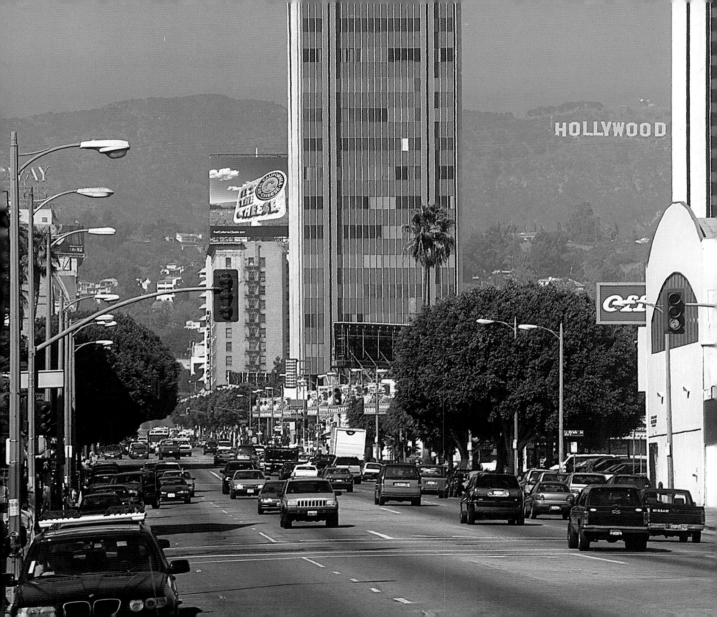

LOS ANGELES
THEN & NOW

ROSEMARY LORD

Thunder Bay
P·R·E·S·S

San Diego, California

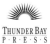

Thunder Bay Press
An imprint of the Advantage Publishers Group
THUNDER BAY 5880 Oberlin Drive, San Diego, CA 92121-4794
P·R·E·S·S www.thunderbaybooks.com

Produced by Salamander Books,
an imprint of Anova Books Company Ltd.,
151 Freston Road, London W10 6TH, U.K.

© 2007 Salamander Books

All notations of errors or omissions should be addressed to Thunder Bay Press,
Editorial Department, at the above address. All other correspondence (author
inquiries, permissions) concerning the content of this book should be addressed
to Salamander Books, 151 Freston Road, London W10 6TH, U.K.

ISBN-13: 978-1-59223-733-3
ISBN-10: 1-59223-733-9

The Library of Congress has cataloged the original Thunder Bay edition as follows:

Lord, Rosemary
Los Angeles then & now/Rosemary Lord. pcm.
ISBN 1-57145-794-1
1. Los Angeles (Calif.)—Pictorial works. 2. Los Angeles (Calif.)—History-Pictorial works.
1. Title: Los Angeles then and now. II. Title.
F869.L843 L66 2002
979.4'94-dc21 2002071950

Printed in China

1 2 3 4 5 11 10 09 08 07

ACKNOWLEDGMENTS

Thanks to Simon Clay for terrific photographs and encouragement. Special thanks
to Ron Kirchhoff for his extraordinary knowledge of Los Angeles. Also special
thanks to Bruce Torrence for his invaluable contributions. Thanks to Dan Strehl of the Hollywood Library
for pointing me in the right direction. Thanks also to Sam Cole of the Hollywood Roosevelt Hotel for
making us so welcome. Thanks to Dace Taube, Curator of the U.S.C. Cultural History Library and
Caroline Cole of the Los Angeles Public Library. And most of all, thanks to my husband Rick Cameron for
his patience, support, chauffeuring, and infinite source of irrelevant historical information.

The photograph on the front cover shows Grauman's Chinese Theater in the twenties (California
Historical Society, Title Insurance and Trust Photo Collection, Department of Special Collections,
University of Southern California). The back cover shows the theater today (Prado-Seward @ SGM).
See pages 92 and 93 for details.

The photograph on the front flap (top) shows St. Mark's Hotel in 1905 (California Historical Society,
Title Insurance and Trust Photo Collection, Department of Special Collections, University of Southern
California). The photograph on the front flap (bottom) shows the hotel today (Simon Clay). See pages
130 and 131 for details.

The photograph on the back flap (top) Union Station in 1939 (California Historical Society, Title
Insurance and Trust Photo Collection, Department of Special Collections, University of Southern
California). The photograph on the back flap (bottom) shows the station today (Simon Clay). See
pages 16 and 17 for details.

Page 1 shows the view from Vine Street in 1925 (California Historical Society, Title Insurance and Trust
Photo Collection, Department of Special Collections, University of Southern California). Page 2 shows
the same view today (Simon Clay). See pages 72 and 73 for details.

PHOTO CREDITS

The publisher wishes to thank the following for kindly supplying the "then" photography for this book:
Front cover, and pages 1, 6, 8, 12, 16, 18, 20, 22, 24, 26, 28 (main), 34, 36, 38, 42, 44, 46, 48, 50, 52, 68, 72, 80,
92, 96 (all), 98, 120, 130, 132, 134, 142 (main and inset), courtesy of the California Historical Society, Title
Insurance and Trust Photo Collection, Department of Special Collections, University of Southern California
Pages 14, 58, courtesy of the Whittington Collection, Department of Special Collections, University of
Southern California
Pages 40, courtesy of the Hearst Newspaper Collection, Special Collections, University of Southern California
Pages 10, 28 (inset), 30 (main and right), 32, 54, 110, 114, 116, 118 (main and inset), 124, 126, 128, 136, 138,
140 courtesy of the Los Angeles Public Library
Pages 56, 60, 62, 64 (main and inset), 66, 70 (main and inset), 74, 76, 78, 82, 84, 86, 88, 90, 94, 100, 102, 104,
106, 108, 112, 122, courtesy of The Bruce Torrence Hollywood Historical Collection.

Thanks to Simon Clay for taking all the "now" photography, with the exception of the photographs on
pages 87 (main and inset), 93 and the back cover, which were supplied courtesy of Prado-Seward @ SGM.

The publisher wishes to thank the Hollywood Roosevelt Hotel, from which the photographs on pages 93,
97, and the back cover were taken.

INTRODUCTION

The Native Americans called Los Angeles the "Land of Smoke" because of the haze that often hangs over the basin early in the morning. They were the first to inhabit the downtown Los Angeles area, which they called Yang-Na. In 1542 when Portuguese-born explorer Juan Cabrillo sailed into the harbor, he saw the smoke from the Native Americans' fires and called it the "Bay of Smokes." The early morning haze still lingers, but Los Angeles has continued to change over the decades, probably more than any other part of America.

For years, Los Angeles was just a stopping-off point between Europe and the Far East for traders of spices and silks. It was not until the Spanish, under Gaspar de Portola's command, arrived at Yang-Na in 1769 that it was claimed and dedicated as "La Reina des los Angeles." The Spanish governor, Felipe de Neve, brought recruits from Mexico, and the forty-four settlers (which included Africans, Native Americans, Spaniards, and Mexicans) officially founded Los Angeles in 1781. Franciscan Father Junipero Serra built missions in an attempt to convert the resident Native Americans to the Christian faith.

The Native Americans were skilled craftspeople and were used as slave labor to build the new town. In 1860 the Native American population was decimated by an outbreak of smallpox, and by 1920 only five percent of the original Native American population had survived. Unlike the fossilized remains of prehistoric animals trapped in time, there are scant traces of the Chumash and Tongva tribes, save a few woven baskets, stone paintings, and place-names such as Malibu, Cahuenga, and Azusa.

The first American in Los Angeles was Boston shipbuilder Joseph "Pirate Joe" Chapman in 1818. A gifted carpenter, he built the Pueblo Plaza Church. As the town spread, enterprising developers advertised: "Room for millions of immigrants, a climate for health and wealth with no cyclones or blizzards." Los Angeles was on its way to becoming a polyglot of nations. The Chinese arrived in 1870 to work as cheap labor in the gold mines and on the railroads. The gold rush also brought folks from far and wide in search of their fortunes. Many immigrants, fleeing religious persecution in Europe, came to New York and from there they made the long overland trek west in covered wagons, searching for freedom and sunshine. The majority of Los Angelenos were born elsewhere—even the palm trees that are so widespread in the area today are not indigenous to the region.

The arrival of Henry Huntingdon's Pacific Electric Railroad in 1900 marked the beginning of the trolley system that linked downtown with the ocean and midtown with the valley. In 1851 the *Los Angeles Star* was the town's first newspaper, while the rival *Los Angeles Times* was founded in 1881. Libraries, museums, schools, and places of worship sprung up. Oil was discovered and the cattle ranchers prospered on this "black gold."

Hollywood was created by Kansas prohibitionist Harvey Wilcox, who sold parcels of his ranch for a development to be called Figwood. However, Wilcox's wife, Daeida, liked the name Hollywood (a city near Chicago), and the name stuck. Little did the puritanical couple know how their innocent-sounding name would be viewed a century later. It was the Hollywood film industry that really put Los Angeles on the map, as the world escaped into their celluloid adventures and followed the often scandalous and extravagant lifestyles of the movie stars.

In 1909 bad weather in Chicago forced director Francis Boggs to complete his film in Los Angeles. *The Heart of a Race Tout* was shot in a vacant downtown Chinese laundry. However, it was New Yorkers Carl Laemmle, Cecil B. DeMille, Jesse Lasky, and Samuel Goldwyn who first built movie studios in Hollywood. DeMille's *Squaw Man* became the first feature to be filmed entirely in Hollywood. The legendary Louis B. Mayer, Jack Warner, David Selznick, and showman Sid Grauman continued the legacy, and soon the Hollywoodland sign symbolized the heart of the movie industry. Hollywood gave us films like *Gone With the Wind*, *The Grapes of Wrath*, and *It's a Wonderful Life*, and continues to enchant us today.

Today, foreign corporations own most of the film studios, and young hopefuls still flock to seek fame and fortune in Hollywood. A small train stop called Morocco became the elegant Beverly Hills area, which contains Rodeo Drive, a shopping mecca for designer fashions. The swinging 1960s saw an effort to wipe out the old and "modernize," and many beautiful buildings were torn down. Fortunately, today there is a new appreciation of the history of the "Queen of the Angels," and historical societies are busy reclaiming and restoring the old buildings.

Surviving disastrous flooding, fires, riots, and, of course, earthquakes, Los Angeles continues to charm residents and visitors alike. People are still lured to the area by a promise of a better life, and the sunshine, blue skies, and palm trees don't hurt either. This revealing book matches historic nineteenth and early twentieth century images with photographs of modern Los Angeles, showing how the multifaceted, multicultural "Dream City" has evolved. "I'm ready for my close-up, Mr. DeMille!"

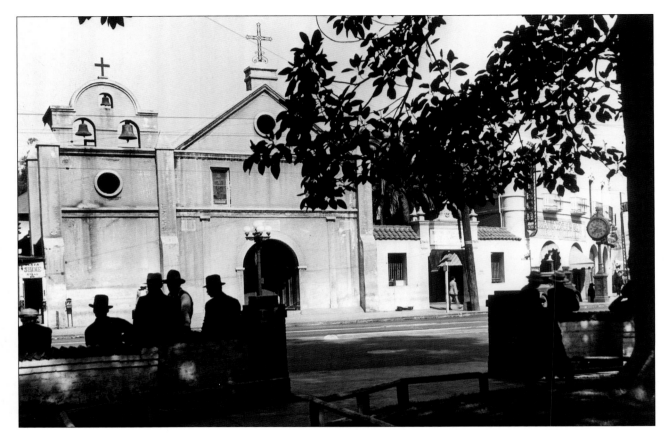

Shipbuilder Joseph Chapman took four years to build *Nuestra Senora la Reina de Los Angeles*—Our Lady Queen of the Angels—Los Angeles's first church, completed in 1822. Until then, the Mission San Gabriel was the nearest place of worship for parishioners who walked the nine miles for Sunday services and holy days. The new church quickly became the spiritual and social center for the pueblo.

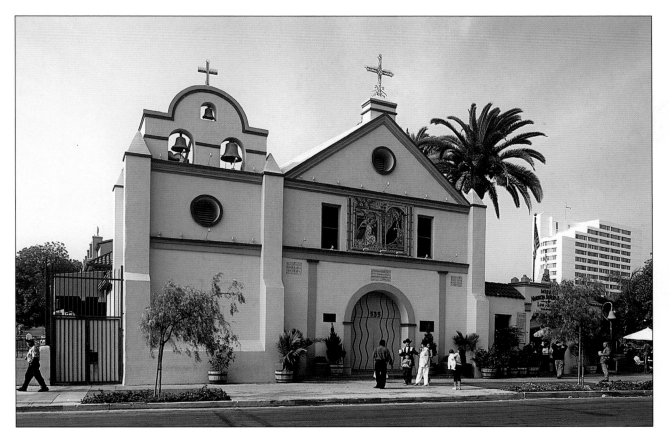

Sparkling with fresh paint, the church is still popular for weddings, christenings, and fiestas. Once boasting the largest Roman Catholic congregation west of the Rockies, the doors are still open to immigrants and refugees in need. Over the years, the Old Plaza Church has had several face-lifts—but the church's role remains the same as it watches over the plaza.

Considered the oldest street in Los Angeles, Olvera Street began as a lane called Wine Street on the north side of the plaza. In 1877, it was renamed in honor of one of its residents, Agustin Olvera, the county's first judge. However, by the 1920s, the historical buildings were neglected and Olvera Street was in terrible disrepair. In 1926, civic leader Mrs. Christine Sterling, shocked to find it now a slum, began a campaign to renovate Olvera Street, enlisting her wealthy and influential friends to save this historic heart of Los Angeles.

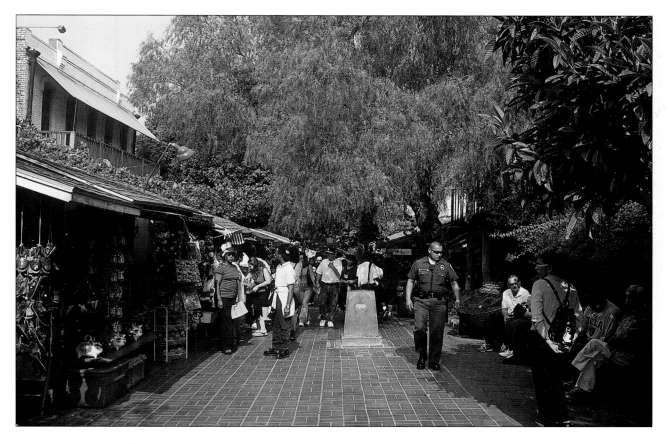

On Easter Sunday, 1930, Olvera Street was reopened (brick-paved by a local prison gang) as a Mexican marketplace, and it became an immediate tourist attraction. The newly renovated Pelanconi House and The Winery were among four Italian structures here, while the 1818 Avila Adobe (Mrs. Sterling's home until her death in 1963) is the oldest existing building in the city. Today this is an exciting tourist and cultural draw with Mexican artifacts, crafts, restaurants, mariachis, and Native American dancers to entertain the visitors.

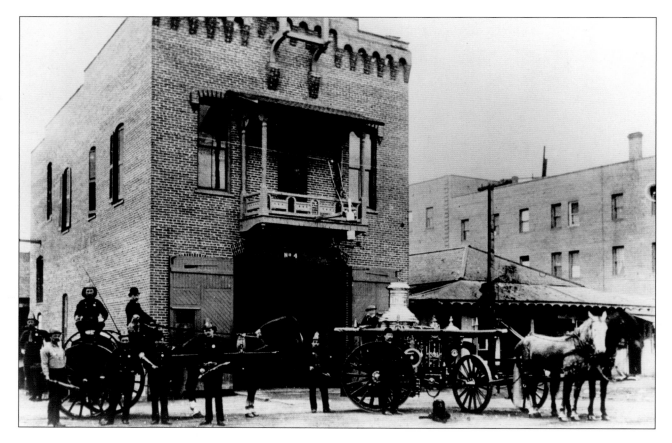

The 1884 Plaza Firehouse was Los Angeles's first city-built fire station. Previously, there were two volunteer firefighter units, but they were constantly bickering and would race each other to the fires! The new firehouse opened in September 1884, with the men housed upstairs and a brass pole for them to slide down to reach the horses that pulled the steam fire engines. However, it was not until December 1885 that the city began paying its firemen.

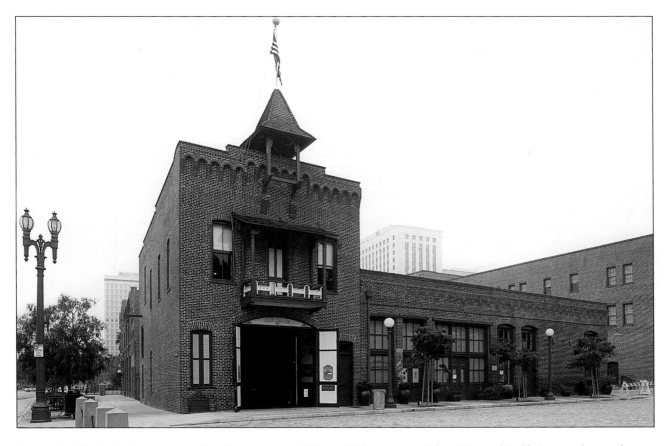

Built on leased land, the fire company was forced to move out in 1897. In the ensuing years, the Plaza Firehouse deteriorated and was used as a cheap boardinghouse, a saloon, and, in 1918, as a Chinese vegetable market with a flophouse upstairs. Bought in 1954 by the State of California as part of their "Historical Pueblo," it was subsequently restored to its former glory and today serves as the Museum of Firefighting and contains historical memorabilia.

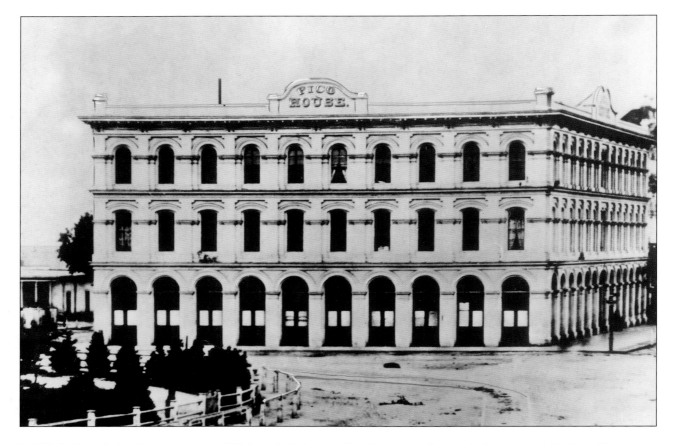

In 1869, Pio Pico, the last Mexican governor of California, built the Italianate Pico House in an effort to revitalize the deteriorating Pueblo Plaza. The first three-story structure there, Pico House was an elegant Ezra Kysor-designed hotel, with luxurious baths, gas lighting, and a French restaurant. Distinguished guests attended balls, wedding receptions, and fiestas. For several years, Pico House was the grandest hotel in Los Angeles—until the community began to move south and the pueblo fell into decline.

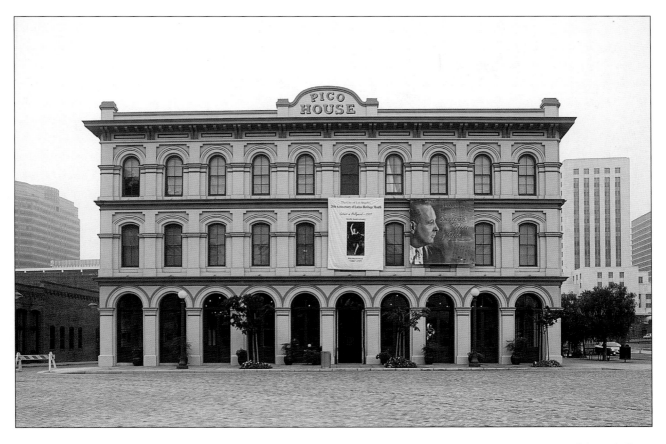

Floods and droughts caused many ranchers to move away from El Pueblo. Pico House and the adjacent Merced Theater were successful for a while, but they eventually declined along with the rest of the area. Pico House was partially renovated in 1981 and again in 1992. After yet another careful restoration, Pico House, now an exhibition hall, had a grand reopening in 2001 with a photographic exhibition entitled "Latinos in Hollywood."

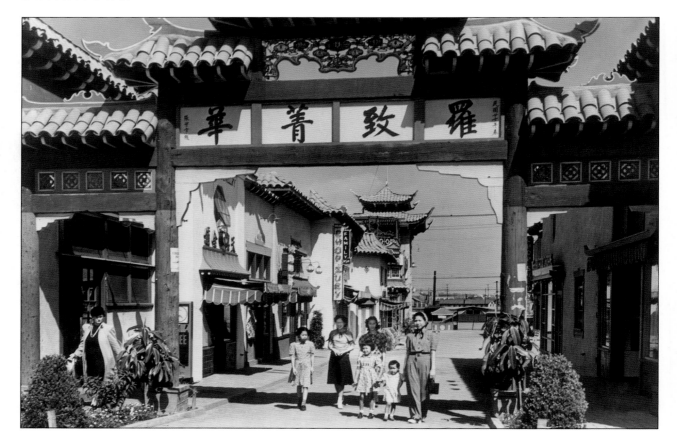

華 菁 致 羅

By 1870, about 300 Chinese people were living in Old Chinatown, south of the plaza, in run-down conditions, plagued with tong wars, prostitution, and opium dens. As they were forbidden to own land, the Chinese were unceremoniously evicted from this area in 1932, which was to be used for the new Union Station. Not permitted to live among the general population, Chinese residents were moved en masse to share Little Italy a few blocks west.

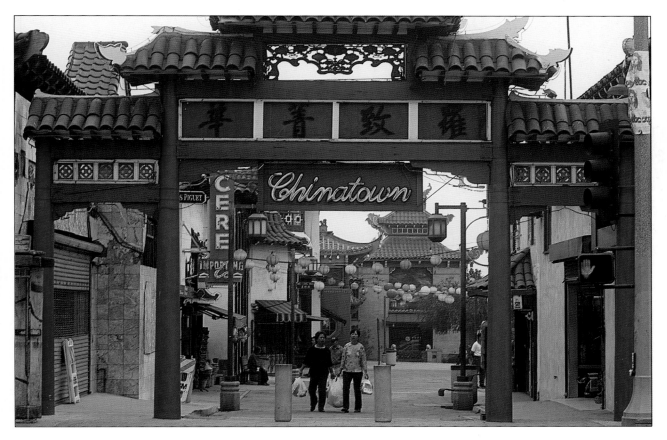

The first "China City" (designed by American filmmakers who filmed scenes for *The Good Earth* there) mysteriously burned down six months later. The new Chinatown seen today, between Broadway and Hill Street, was built in the 1930s on Chinese-owned land, with Chinese input, to provide modern amenities and comfort while retaining Chinese tradition. Chinatown quickly became a favorite with Los Angelenos and tourists who loved the exotic food and low prices.

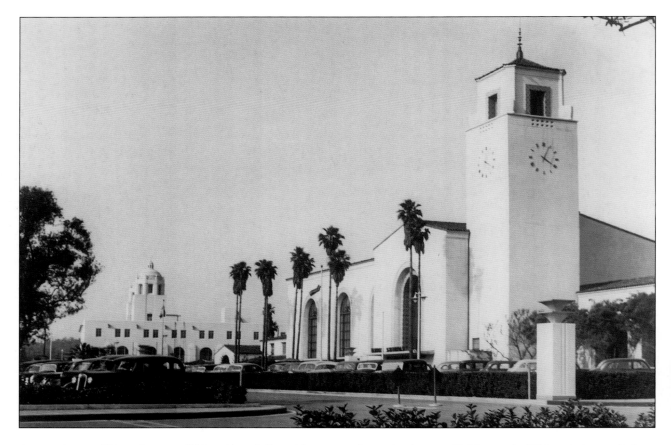

A civic gala opened Union Station in 1939 on Alameda Street (the former site of Old Chinatown), opposite the plaza. It served the Southern Pacific, Santa Fe, and Union Pacific Railroads, and was designed by John and Donald Parkinson in a Spanish Mission style with carved ceilings, marbled floor, and a 135-foot clock tower. Before modern jets, Union Station was the arrival and departure point for all Los Angelenos, including wartime GIs and movie stars such as Greta Garbo and Cary Grant.

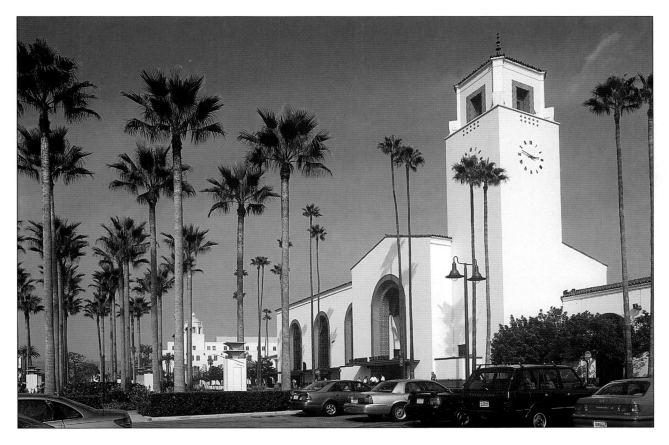

Considered the last of America's great railway stations, Union Station fell on hard times when air travel became popular in the 1970s. However, many films were shot here, including *The Way We Were* and *True Confessions*. The 1990s saw a resurgence when the Metro Line Subway Terminal opened and Amtrak's Coastal Starlight and San Diegan became popular. With a recent renovation and the fancy new Matrix restaurant replacing the old coffee shop, Union Station gleams proudly once more.

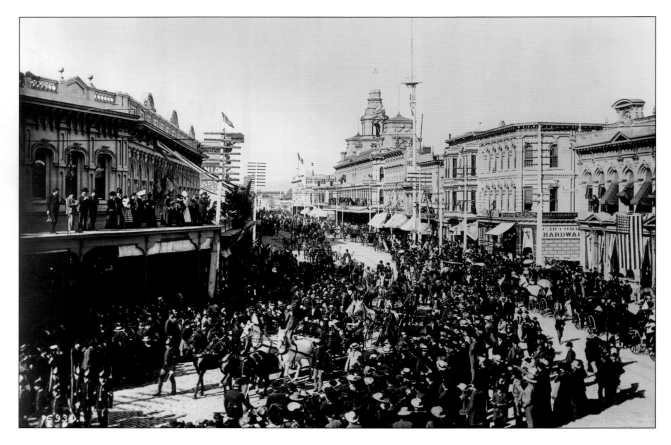

In 1896, the Silver Republicans had a parade for their candidate, William Jennings Bryan, and crowds gathered to cheer and enjoy the fiesta along Main Street. In the center is one of the first 150-foot lampposts. Along the right side are the famous Pico House, the 1870 Merced Theater (Los Angeles's first theater), Masonic Hall, and the Bella Union Hotel. Horsecars ran down Main Street as late as 1897.

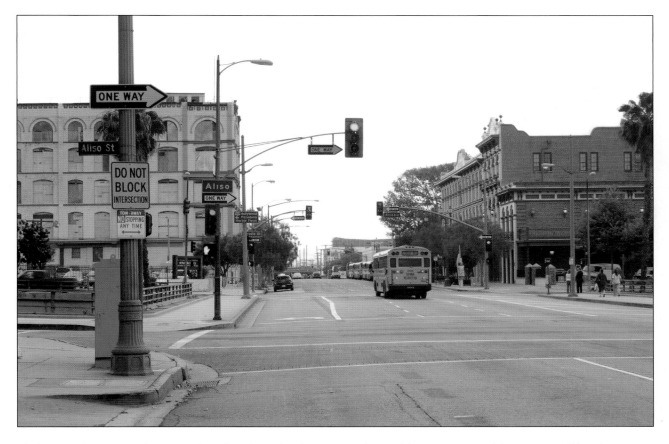

The horses are long gone and so too are the trolleys that replaced them. Today the site where Temple and Spring Streets met Main Street has been demolished, and the Hollywood Freeway runs underneath the now elevated Main Street. The Bella Union Hotel was destroyed, but Pico House and the Masonic Hall have been renovated. The main foreground seen in the archival photograph is now the site of government buildings, including the Criminal Court Building and Hall of Records.

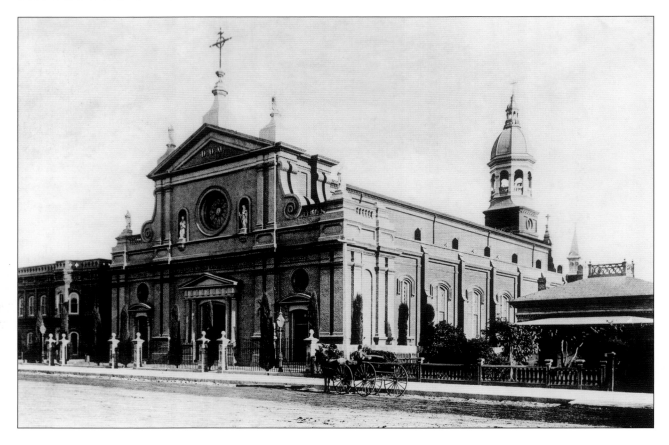

The Cathedral of St. Vibiana, seat of the Los Angeles Archdiocese, was completed in 1876 when Los Angeles's population reached 5,500—3,000 of whom were Catholics. Designed by Ezra Kysor, it was modeled after a Baroque church in Barcelona, on land donated by Amiel Cavalier at a cost of $80,000—and seats well over a thousand. Inside, preserved in a marble sarcophagus, are the relics of the early Christian martyr St. Vibiana.

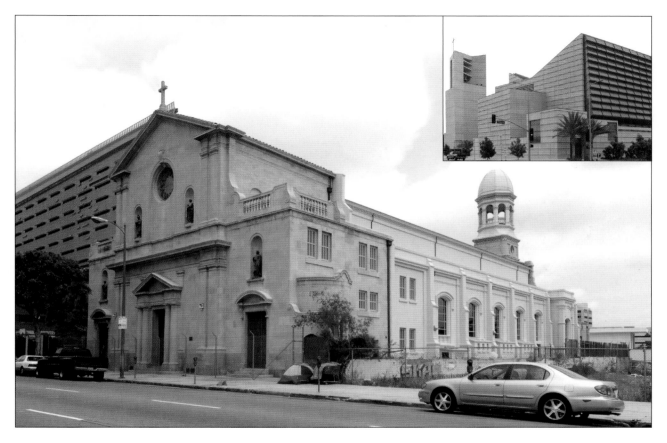

The Cathedral of St.Vibiana was severely damaged by earthquakes in 1971 and 1994. Surrounded by abandoned buildings and bordering Skid Row, the neglected cathedral was closed in 1995. The archdiocese proposed tearing down St. Vibiana's. After much public protest, the cathedral was saved and bought by developer Tom Gilmore, who is currently converting the historic building into a school and performing arts center at a cost of $45 million. The Los Angeles archdiocese built a new $200 million cathedral (inset) at 555 W. Temple Street. Named Our Lady of the Angels, it was opened in September 2002.

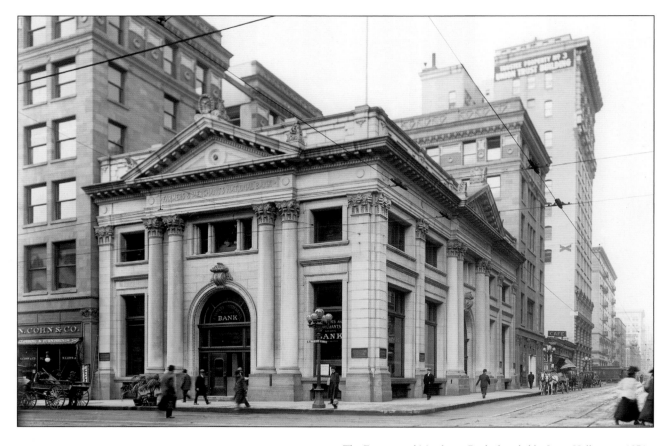

The Farmers and Merchants Bank, founded by Isaias Hellman in 1871, was the first incorporated bank in Los Angeles. Photographed in 1908, the Farmers and Merchants Bank on the corner of Main and Fourth Streets was built in 1905 and was designed by the firm of Morgan and Wells. Isaias Hellman, a real estate speculator, merchant, and banker, remained president of the bank until his death in 1920.

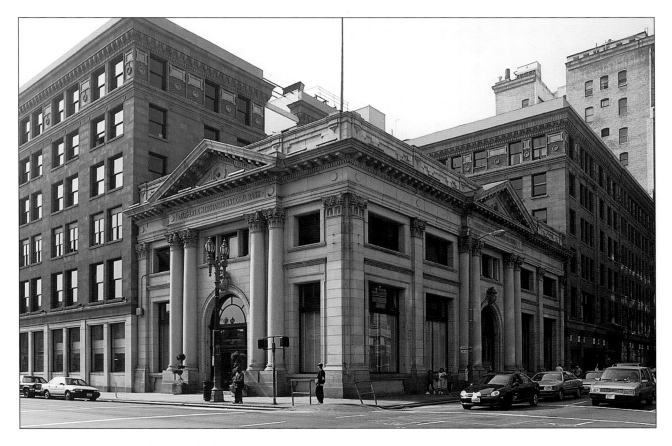

The last surviving example of beaux arts banking temples, Farmers and Merchants Bank operated as a bank until its closure in the late 1980s. Many of the original rooms, light fixtures, and skylights remain. Since then, its Roman elegance has been used for film locations and many special events. Developers are currently renovating the building, offering luxurious loft apartments, an art gallery, and banquet facilities.

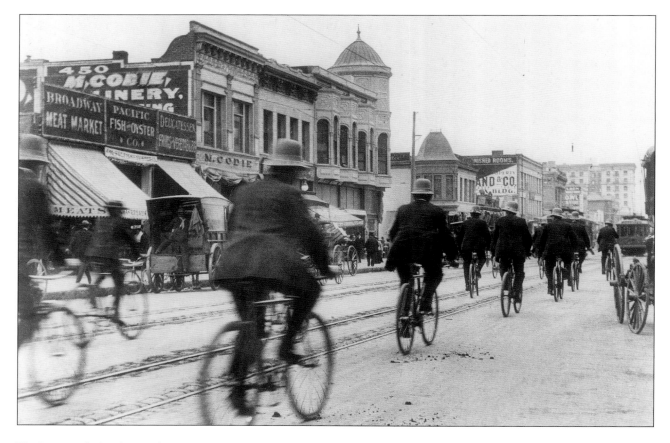

The first type of police force in the city was a group of volunteers, the Los Angeles Rangers, who assisted the city marshal in 1853. The Los Angeles City Guards, who wore the first official police uniform, soon succeeded them, and the first horse patrol trotted down the streets in 1875. By the late 1800s, bicycles had become a favorite form of transportation and it was no surprise to find the Los Angeles Police Department patrolling on their bikes. The bike patrol seen here is covering Broadway in 1904.

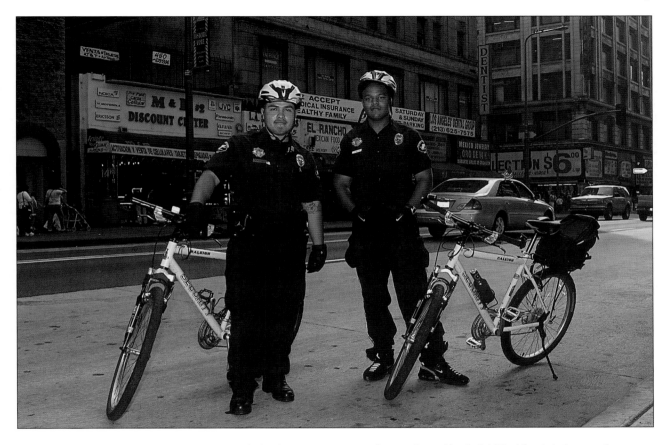

Today the Los Angeles Police Department is overworked and understaffed, so in the downtown business district, the organization Historic Core was formed to protect and serve local businesses. Historic Core hires a private security company to patrol the neighborhood, using officers authorized by the LAPD. After dark they patrol in cars, while in the daytime they patrol on bicycle—just as the police did over a hundred years ago.

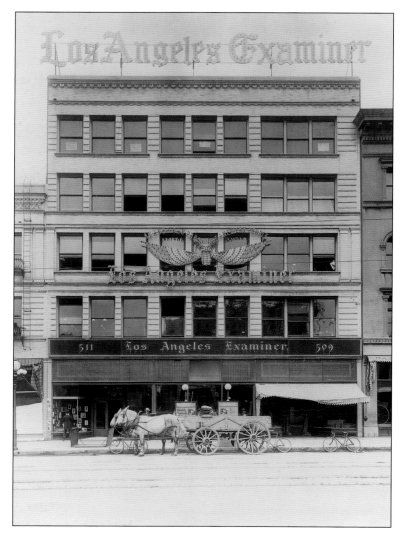

In December 1903, William Randolph Hearst began publication of his latest newspaper, the *Los Angeles Examiner*, in this building at 509 Broadway, pictured here in 1906. He later commissioned a larger building in the mission revival style a few blocks down on Broadway, into which the newspaper moved in 1915. Hearst then acquired the *Herald* and *Express* newspapers in the 1930s, merging the morning and afternoon papers into the *Herald-Examiner* in 1962. It became notorious for its shocking headlines.

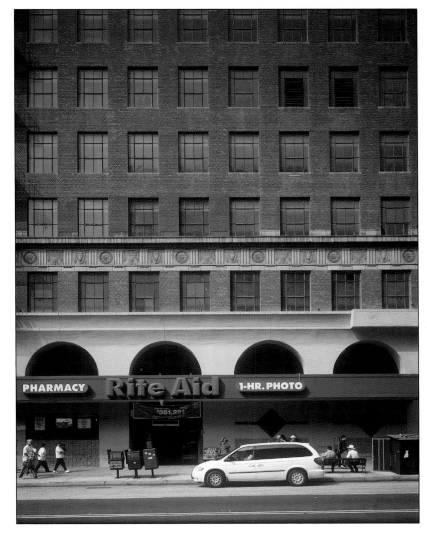

The *Herald-Examiner* ceased publication in 1989. The original *Los Angeles Examiner* building was replaced in 1924 with a similar-style structure used for offices. After years of neglect, it has been spruced up and is currently home to a drugstore. The later *Examiner* Building on Broadway also fell on hard times and lies empty. Both buildings are now under the protection of the local Historical Society.

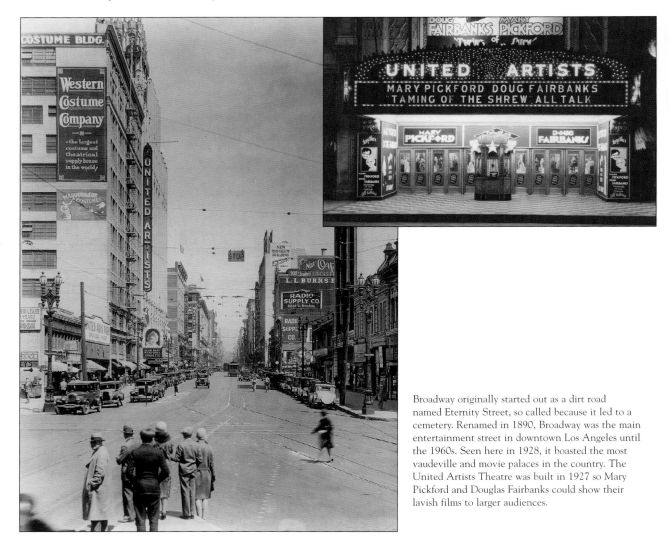

Broadway originally started out as a dirt road named Eternity Street, so called because it led to a cemetery. Renamed in 1890, Broadway was the main entertainment street in downtown Los Angeles until the 1960s. Seen here in 1928, it boasted the most vaudeville and movie palaces in the country. The United Artists Theatre was built in 1927 so Mary Pickford and Douglas Fairbanks could show their lavish films to larger audiences.

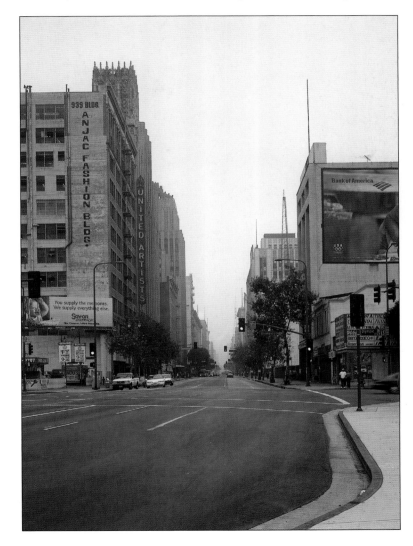

When businesses and entertainment venues became decentralized, this part of Broadway was gradually abandoned and a largely immigrant population of vendors has taken over the gracious old theaters of the 1920s. The expensive stores and restaurants are gone and the wonderful old movie palaces are now gift or discount shops with Latin music emanating from them. The Spanish-Gothic United Artists Theatre is now Gene Scott's University Cathedral with a "Jesus Saves" sign overhead, and the elaborate interior has been renovated with Scott's own murals.

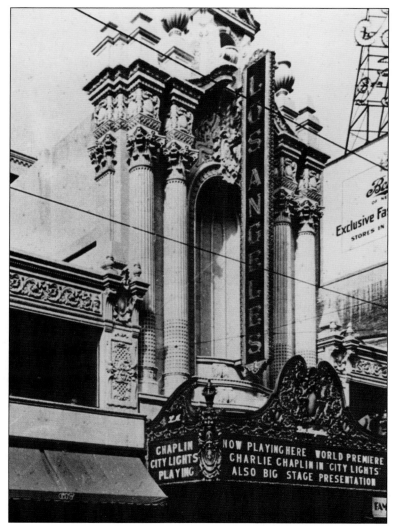

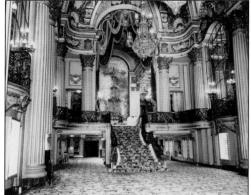

The Los Angeles Theatre was built in 1931 for the opening of Charlie Chaplin's film *City Lights*. With only thirty days to go before the scheduled premiere, the entire theater was constructed off-site and was swung in, slotted between the existing buildings. The most lavish of movie theaters, the French Baroque interior had a central staircase and gold brocade drapes more befitting an opera house, and it cost more than a million dollars.

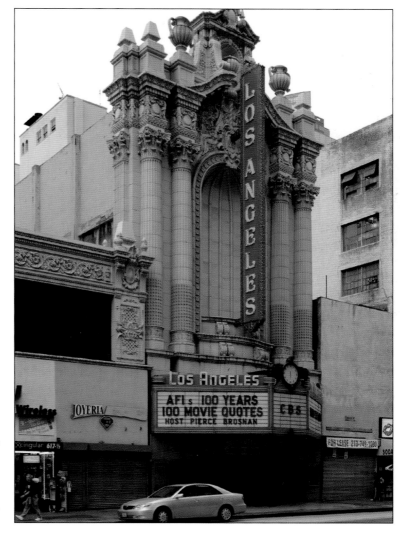

With the hoopla of jazzy premieres behind it, like many others, the Los Angeles Theatre fell into disrepair. After years of being empty, it survived by showing Mexican films and then was used as a backdrop for film shoots, music videos, and special events. The Los Angeles Conservancy has sponsored showings of classic movies here and at other Broadway movie theaters in order to revive and restore the "Dream Places." The Los Angeles Theatre is currently closed . . . awaiting another revival.

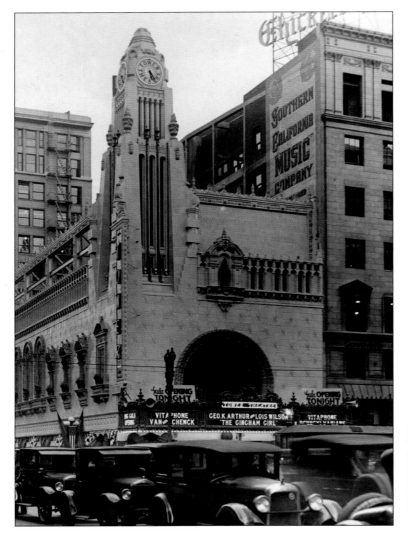

In 1927, S. Charles Lee's first theater design, the Tower Theatre, opened. Seating 1,000 on a tiny site, it was built in powerful Baroque style with innovative French, Spanish, Moorish, and Italian elements all executed in terra-cotta. The very top of the clock tower was removed after the 1932 earthquake. This was the first downtown theater to play "talking pictures."

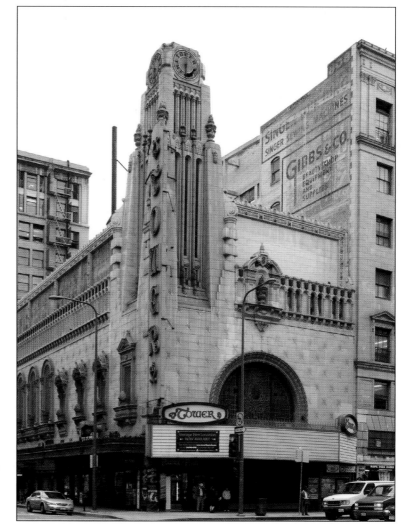

Like so many other theaters on Broadway, the Tower Theatre was abandoned for many years. It remained mostly intact, if rather scruffy, with its famous tower still standing. The lobby was rented to vendors, and the theater was used for film locations in *The Omega Man*, *The Last Action Hero*, and *Coyote Ugly*. More recently, the Living Faith Evangelical Church has begun renting the Tower Theatre.

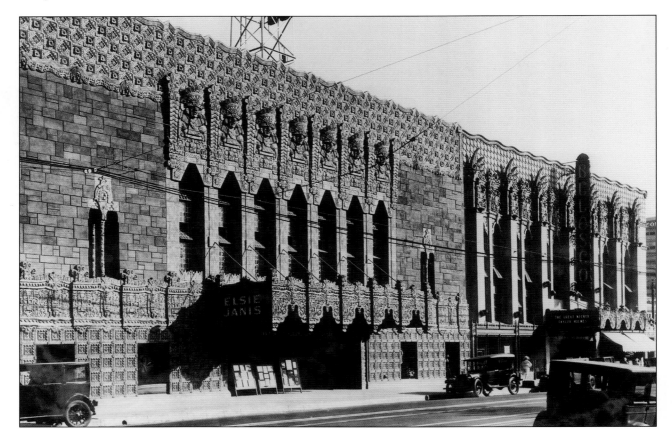

Pre-Columbian inspired with Mayan chieftain heads on the columns outside, the Mayan Theatre was built in 1926 and designed by Morgan, Walls, and Clements. At 1044 South Hill Street, although not on Broadway, it was still part of the heyday of theater extravaganzas. It opened with George Gershwin's musical *Oh, Kay* on August 15, 1927, and was a musical comedy theater for many years before showing motion pictures.

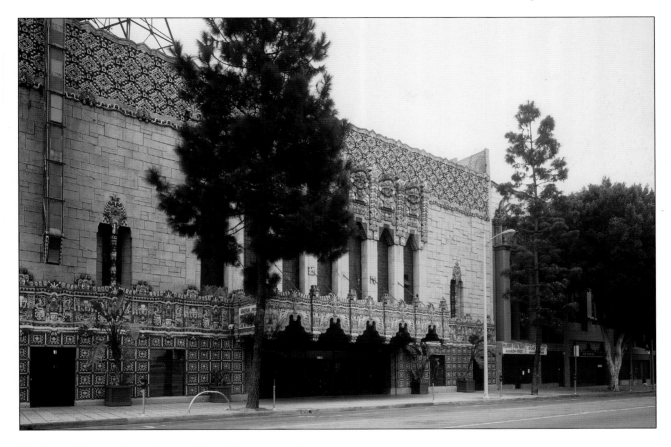

The Mayan Theatre had several years of disuse before it was used to show Spanish-language films. Due to Hispanic influence, it was renovated and opened as a nightclub, enjoying great success as the Salsa Club. The interior was featured in the Kevin Costner film *The Bodyguard*. The adjacent Belasco Theatre has been neglected for many years and is currently available for film shoots.

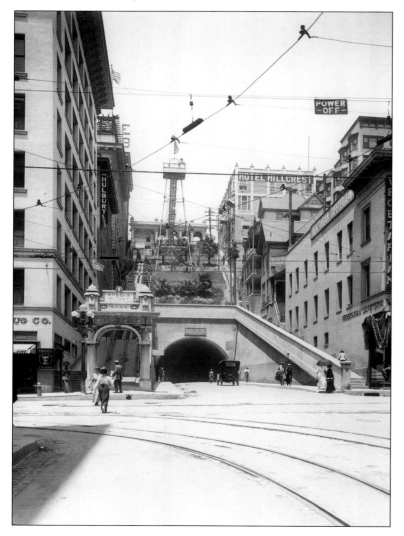

In 1901, J. W. Eddy built the Los Angeles Incline
Railway at Third and Hill Streets to connect downtown
with the upper-class residential area of Bunker Hill.
Soon renamed Angel's Flight and dubbed "the world's
shortest railroad," its two counterbalancing white cars,
Sinai and Olivet (named after biblical mountains),
descended and ascended the hill for one penny each
way until 1953, when the price was raised to a nickel
for a round trip. The archway was added in 1908, and
in 1930, the cars were painted orange and black.

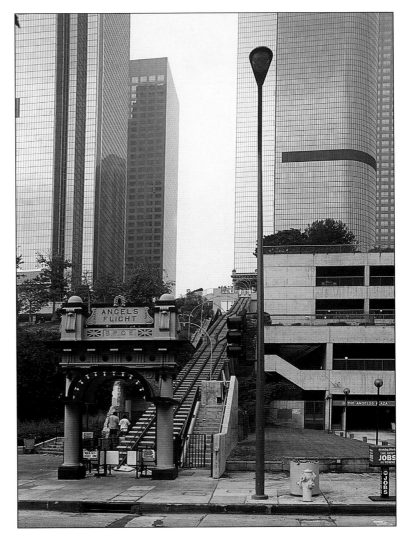

By the 1960s, Bunker Hill had become a slum and was replaced with office buildings and a senior citizen condominium complex. Angel's Flight was dismantled and stored. Thirty years later, in 1996, the new Angel's Flight was installed just a half-block south of the original location. At twenty-five cents a ride, the new Angel's Flight was highly popular until an accident occurred on February 1, 2001 when one passenger was killed and seven injured. It remains closed.

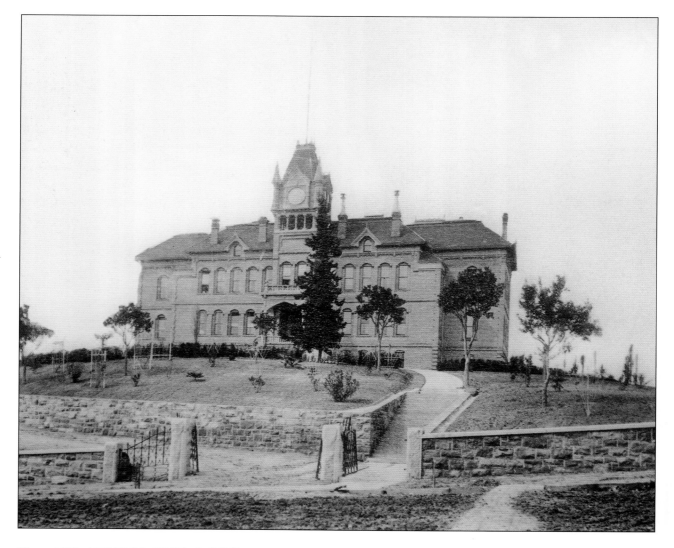

Left: In the 1880s, the growing population of Los Angeles needed a place of learning, and in 1882 the State Normal School opened and welcomed its first students (most of whom were women). By 1914, the school had moved to a larger facility on Vermont Avenue. Ever-growing, in 1919 the newly named Southern Branch of the University of Los Angeles (later UCLA) began a search for a larger site, which was eventually found in Westwood. The original school site at Fifth and Grand became the home of the Los Angeles Public Library.

Right: The new Central Library Building, specially designed by Bertram Goodhue, opened in 1926 with numerous entrances, tide pools, and lawns. These were gradually reduced with the growth of downtown and the need for parking space. After two arson fires in the 1980s, the library was carefully restored (at a cost of $125 million) and expanded with four stories above and four stories underground, as well as a stunning rear atrium. Today the library facade looks exactly as it did in 1926.

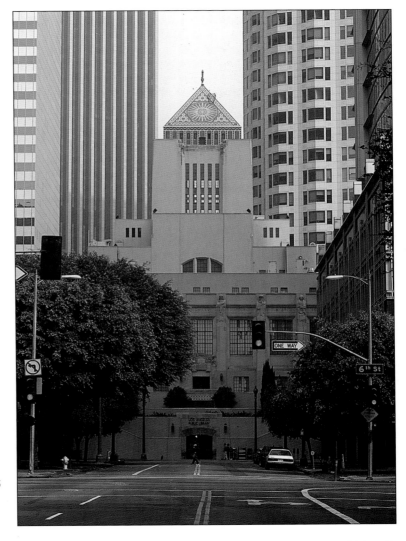

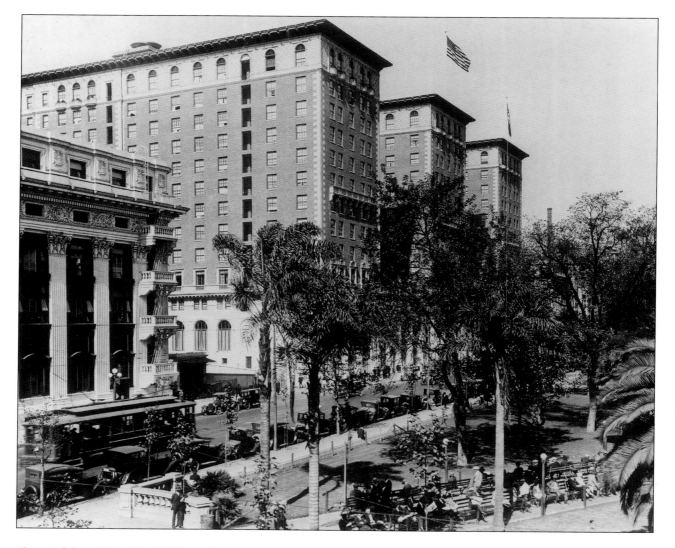

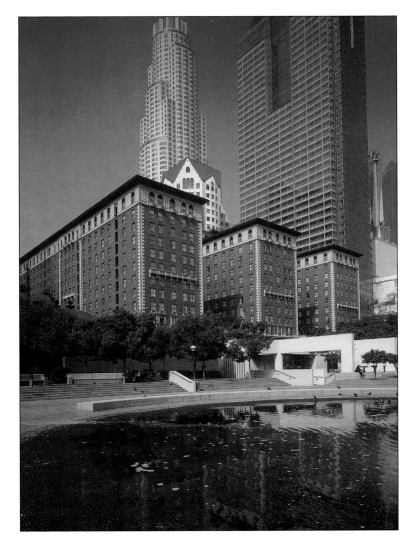

Left: Designed by Schultze and Weaver, the $10 million Biltmore Hotel opened on October 1, 1923 with 1,500 rooms. Foreign royalty and Presidents Roosevelt, Truman, Kennedy, Carter, and Reagan all slept here. The Academy of Motion Picture Arts and Sciences was founded in the Crystal Ballroom, where the first sketch of "Oscar" was scrawled on a hotel napkin. Everything from Academy Award dinners to John F. Kennedy's Democratic Convention happened here, and the Beatles were once helicoptered onto the hotel roof and hid here for days.

Right: The hotel has been refurbished a number of times over the years. The new owners of the newly named Regal Biltmore Hotel undertook a $40 million restoration project in 1984 in which they added an office tower and relocated the main reception area to the Grand Avenue side. Afternoon tea is now served in the former lobby, now called the "Rendezvous Court." A. B. Heinsbergen, son of the Biltmore's original decorator, did extensive mural restoration.

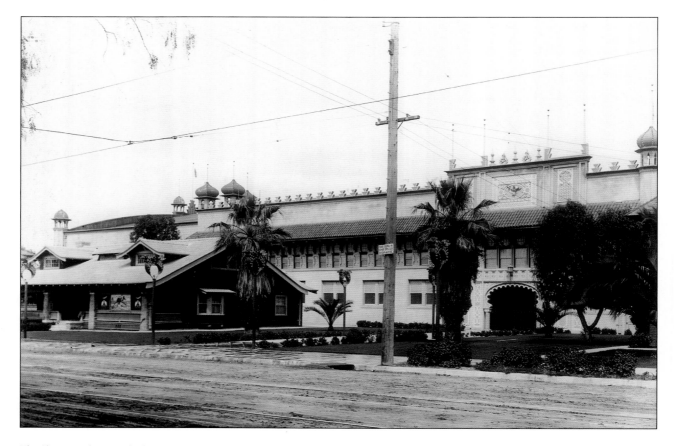

The Shrine Auditorium, built in 1906, was a triumph of architecture and engineering. The auditorium, seen here in 1910, caught fire on January 11, 1920, and was destroyed in thirty minutes. When the architects built the current Shrine Auditorium in 1926, they were able to make it earthquake and fire resistant. John C. Austin's ornate Moorish design was based on the Arabian-Egyptian Masonic symbolism. The huge stage (65 x 185 feet) and seating capacity of 6,300 make this a popular venue for award shows.

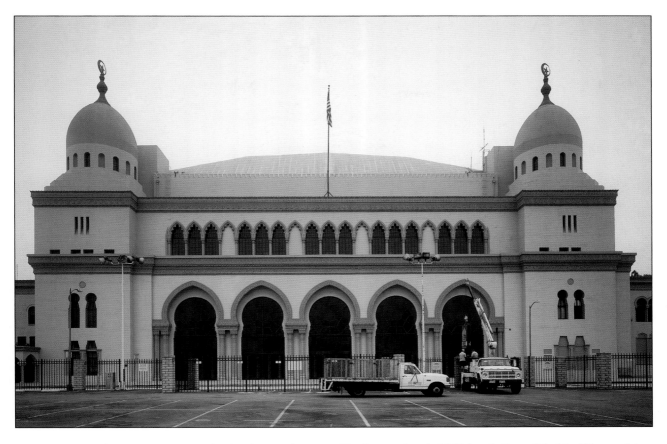

The Academy Awards show was first presented at the Shrine Auditorium in 1947 and returned, temporarily, to the auditorium in the late 1980s. The Bolshoi Ballet, Mikhail Baryshnikov, Bruce Springsteen, and Michael Jackson have performed here, and *King Kong* was filmed here.

The Grammy Awards, MTV Awards, Comic Relief, Soul Train, and the Screen Actors Guild Awards have all found a home at this "West Coast Taj Mahal," with its Pavilion Ballroom, which has room for 5,200 diners and 7,500 dancers.

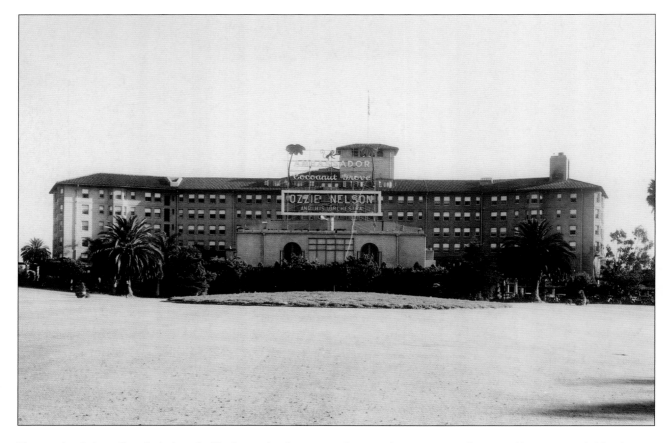

The sprawling Italian villa-style Ambassador Hotel opened on January 18, 1921 and quickly became the place to be seen. Joan Crawford, Bing Crosby, and Loretta Young were discovered here. Judy Garland sang at its famed Cocoanut Grove nightclub, nicknamed "Playground to the Stars." In the 1930s, six Academy Award banquets were held at the Ambassador, and the first Golden Globe ceremony was held here in 1944. However, it found unwanted fame with the tragic assassination of Robert Kennedy in 1968, after he had won the Democratic nomination.

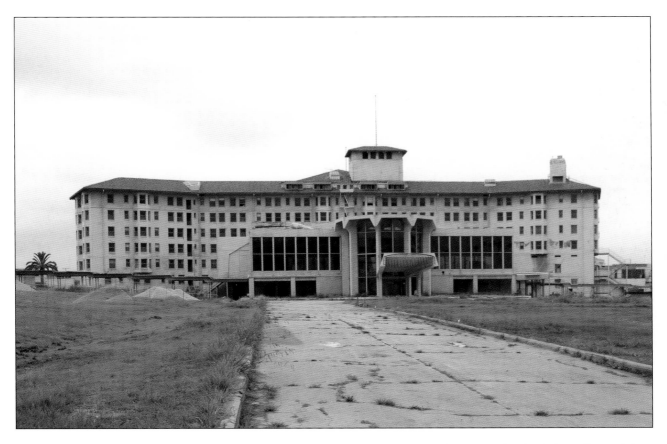

The Ambassador Hotel has been featured in many films, including *A Star Is Born*, *The Graduate*, and *Forrest Gump*. Registered as a historic site, this world-famous hotel was closed in 1989 but continued to be rented out for filming. Tycoon Donald Trump tried to buy the hotel and its twenty-four-acre grounds to restore it as a resort. But the Los Angeles Unified School District purchased it for $75 million and plans to demolish everything but the Cocoanut Grove to build a new school here. Supporters trying to save this historic landmark have not given up the battle, and the lawsuits continue.

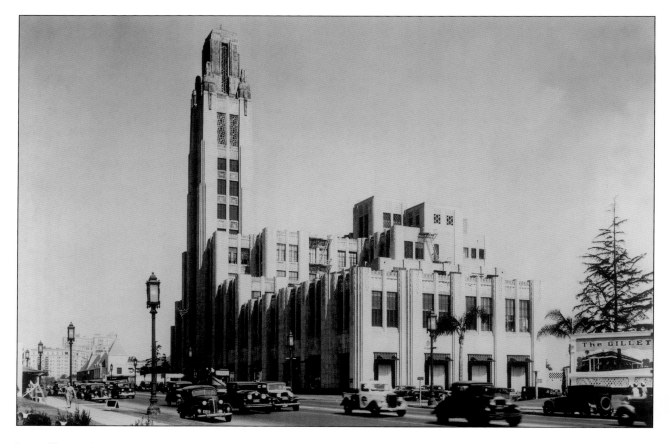

Inspired by new designs at the Paris Exposition, John Bullock, with John and Donald Parkinson, created the magnificent art-deco Bullocks Wilshire building in 1929 as a mecca for well-heeled shoppers. With its distinctive copper-clad tower and glazed terra-cotta tile, the main entrance was at the rear, complete with uniformed parking valets. Greta Garbo, Marlene Dietrich, John Wayne, Clark Gable, and Barbara Stanwyck were devoted patrons, and Cary Grant filmed *Topper* here in 1930.

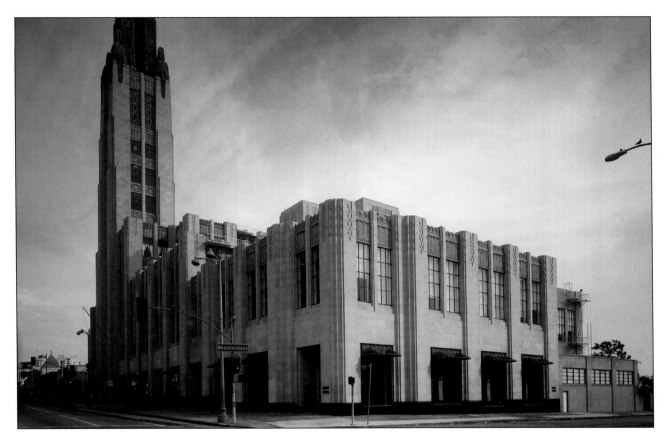

Shoppers moved west as shopping malls sprang up, and Bullocks Wilshire fell into decline. The famous tearoom, with fashion shows while the "ladies who lunch" ate dainty sandwiches, was popular until the end. Angela Lansbury had worked there as a young girl and now came to film *Murder, She Wrote* in this popular setting for films and commercials. When Bullocks Wilshire finally closed in 1996, it was bought and lovingly restored to all its former splendor for the Southwestern University School of Law.

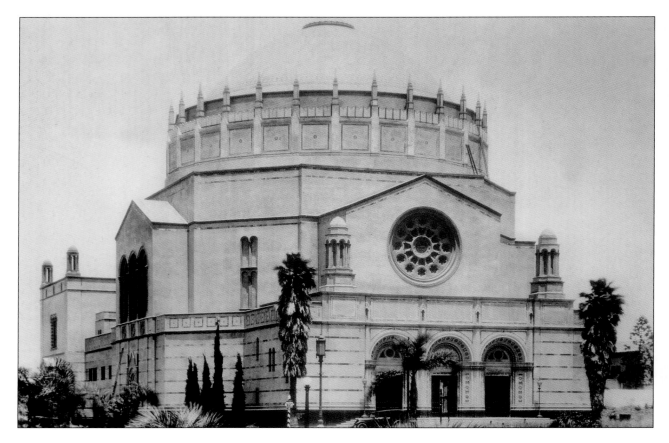

In 1862, B'nai B'rith was the first Jewish congregation in Los Angeles. Ten years later, they built their first temple on Fort Street, now Broadway. As membership increased, they finally moved to this imposing Byzantine-inspired temple on Wilshire Boulevard in 1929, resulting in the name being changed to Wilshire Temple. Designed by Edelman, Norton, and Allison, this is one of the largest and most influential reform synagogues. Al Jolson, Jack Benny, Irving Thalberg, and many celebrities and studio bosses attended temple here.

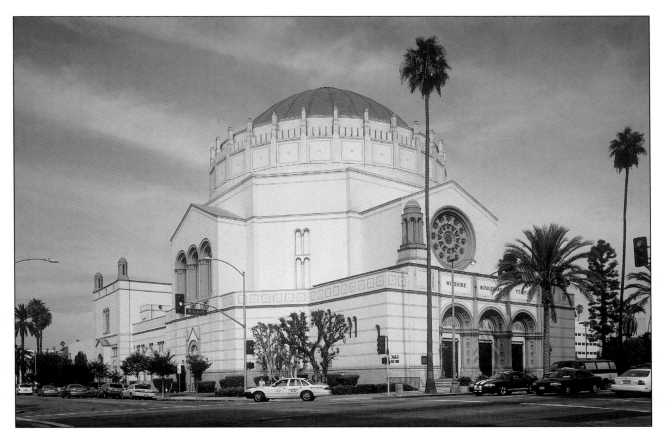

Architecturally outstanding, the building has been listed in the Register of Historic Places. In recent years, Wilshire Temple has continued to grow. Among the many philanthropic projects instituted by the temple are Camp Hess Kramer in Malibu and the 1998 West Los Angeles Community and Cultural Center, Irmas Campus. The Jewish members of the entertainment community continue to be devoted supporters of the famous Wilshire Temple.

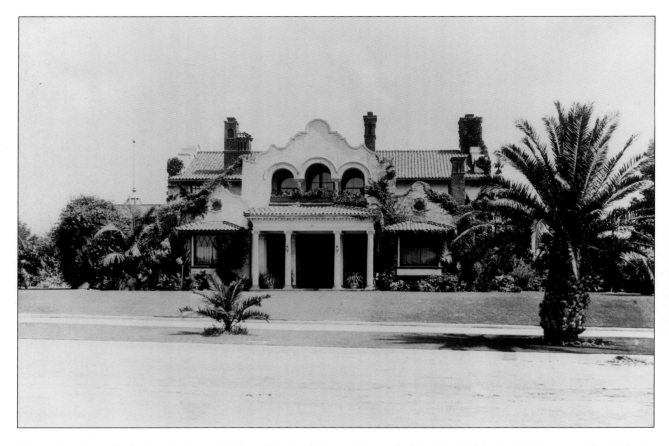

Harrison Gray Otis arrived in Los Angeles in 1881 from Ohio. In 1886, he took over ownership of the *Los Angeles Times*. A real estate tycoon, he shaped much of young Los Angeles and helped bring Owens River water to Los Angeles. When he fought organized labor, two of his workers bombed the *Times* Building in 1910 in protest. After his death, his son-in-law Harry Chandler took over the *Times*. He bequeathed his ornate Spanish-style residence to the county, which used it for the Otis Art Institute.

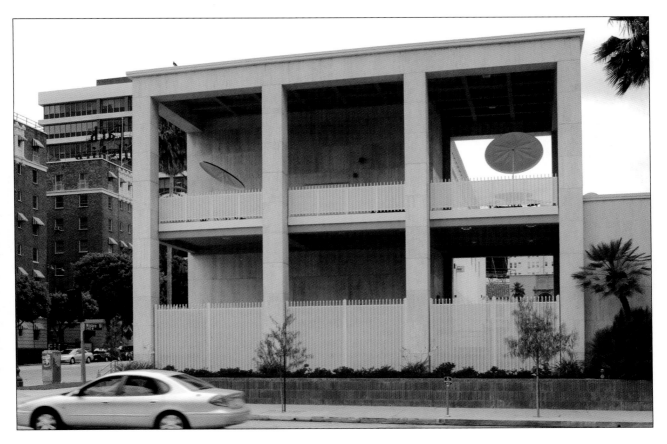

Established in 1918, the Otis Art Institute was the oldest and most prestigious in the West. The old Otis house was replaced with this modern building, and the institute merged with New York's prestigious Parson School of Design in 1978. In 1991, it reverted to the Otis College of Art and Design. The building on Wilshire Boulevard now houses the Charles W. White Elementary School. In 1997, the Otis Art College moved away from what it considered a declining neighborhood to a new location at 9045 Lincoln Boulevard.

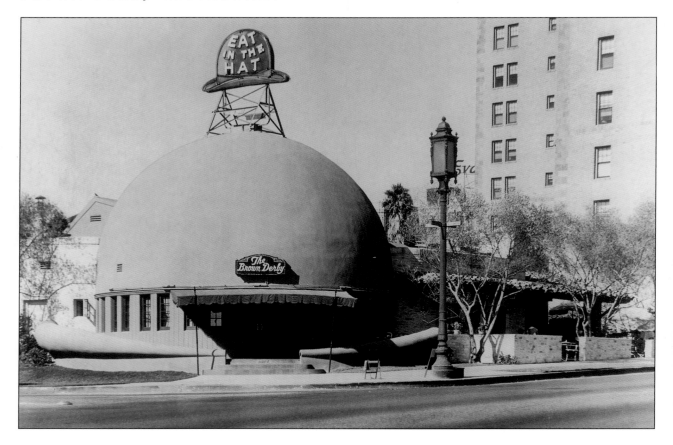

Gloria Swanson's husband Herbert Somborn owned the original Brown Derby Restaurant on Wilshire, opposite the Ambassador Hotel. Its unique shape made it famous. A second Brown Derby was opened at 1628 North Vine Street in 1928, in Cecil B. DeMille's building. In the heart of Hollywood, it soon attracted studio folk and movie stars such as Clark Gable, Loretta Young, John Barrymore, and George Raft. An artist offered to sketch the famous patrons in return for food—and so the "Wall of Famous Caricatures" began.

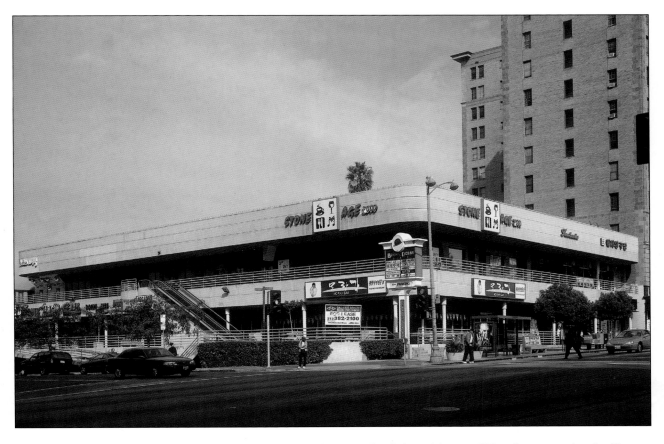

When the restaurant was demolished, the huge derby hat was promised preservation. The original dome-like hat now sits on top of a mini-mall and houses a Korean café. The Vine Street Brown Derby finally closed in 1985, sadly burned down in 1988, and is now a parking lot. The memories of the restaurants, with the famous Cobb salad—named after one of the owners, Robert Cobb—live on.

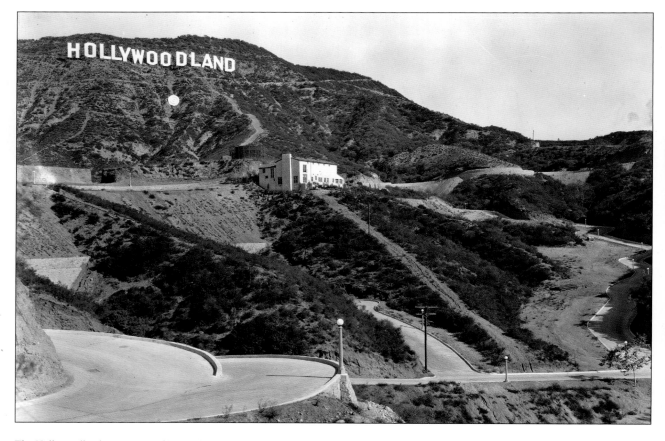

The Hollywoodland sign on top of Mount Lee was erected in 1923 by developers as an advertising gimmick. Costing $21,000, each letter was fifty feet tall and thirty feet wide and made of white-painted metal squares studded with 4,000 twenty-watt bulbs. These were changed as needed by a caretaker who lived in a small house behind the sign. A thirty-five-foot white-painted metal circle (seen as a small white dot from miles away) was put 200 feet below as an eye-catcher.

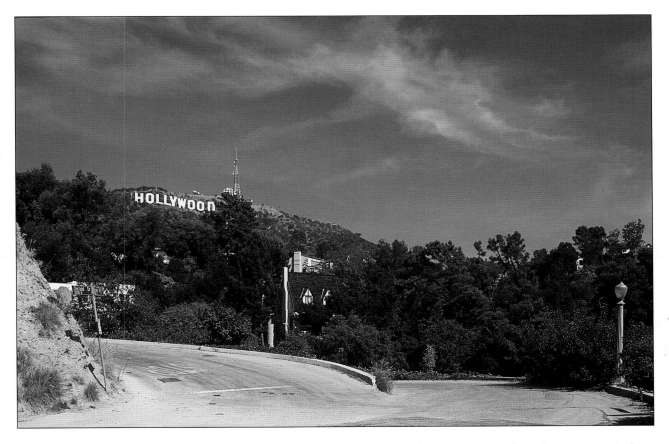

An inspiration to many, the Hollywoodland sign spelled shattered dreams to actress Peg Entwhistle who, in 1932, jumped from the letter *H* to her death fifty feet below. In 1939, maintenance ceased and 4,000 light bulbs were stolen by vandals. Developers decided to donate the sign to the city. Threatening to tear it down, the city compromised— "Hollywood" would be restored without the "land." The sign is now maintained by devoted loyalists who fought to ensure the preservation of this recognizable Hollywood symbol.

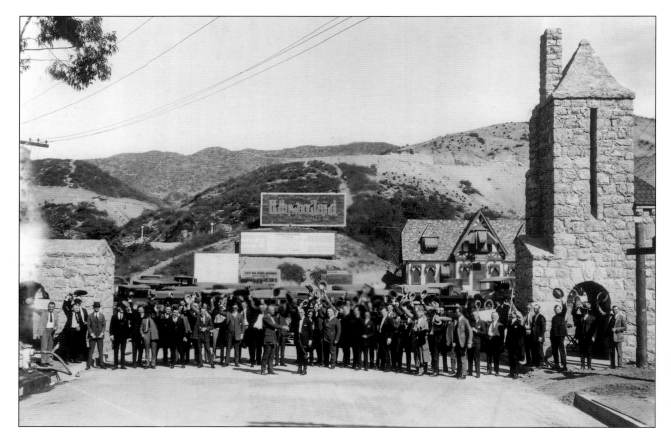

Developer Albert Beach paved the way to the Hollywood Hills with a road he named after himself: Beachwood Drive. In 1923, the director of Pacific Electric Railway, M. H. Sherman, joined Harry Chandler, Tracey Shoults, and developer S. H. Woodruff, and formed Hollywoodland Tract Realty with an office at the Hollywoodland entrance. They built two stone towers on either side and planned to gate the community with a guard on night duty—but the gate and the guard never materialized.

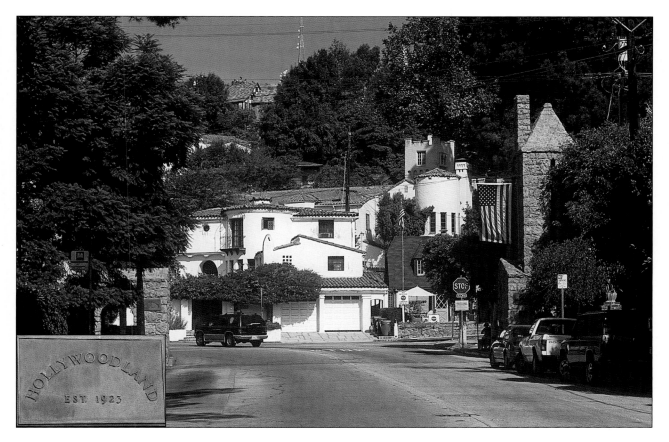

Relatively unchanged, Beachwood Village today is home to successful writers, actors, and artists. Underneath the Hollywood sign, Beachwood Canyon now stops at the Sunset Ranch where cowboys, actors, and horse-lovers alike stable their horses and ride through the Hollywood Hills at sunset. The Village Café is a family café where stars go for breakfast with the rest of the world. Next to the café are a supermarket and a small antiques store.

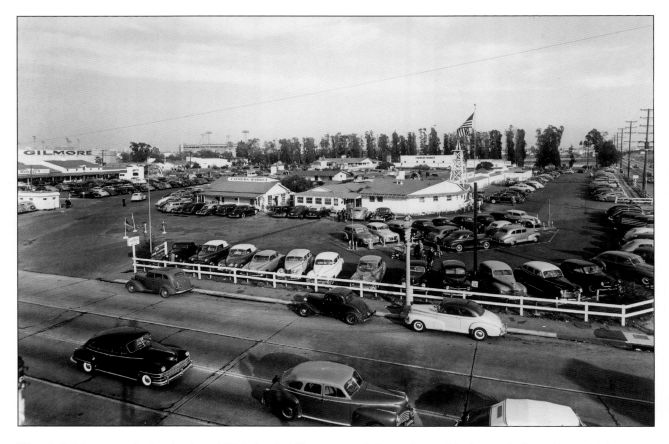

When A. F. Gilmore moved to Los Angeles in 1870, he bought 256 acres for dairy farming. In 1900, while drilling for water for his cows, he hit oil. By 1905, the farm was gone and the Gilmore Oil Company took its place. Farmers rented a corner of "Gilmore Island" at Third and Fairfax to sell their produce, and this became the famous Farmers Market. Gilmore Stadium, built for auto racing, was home to the Bulldogs, Los Angeles's first professional football team. Gilmore Field, constructed in 1938, was also home to the Hollywood Stars baseball team.

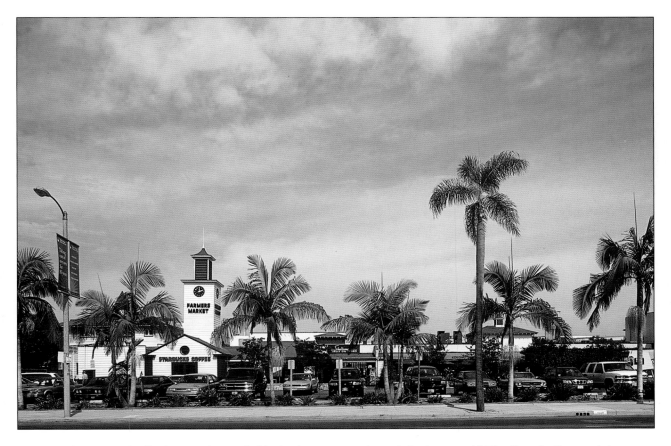

In 1921, Arthur's son, Earl Bell Gilmore, took control of the family business as Gilmore Oil prospered. In 1941, the growing Farmers Market received the new clock tower. When CBS Television Studios replaced Gilmore Stadium in 1952, Gilmore Field became a parking lot. The recent addition of "The Grove" shopping plaza, which opened next to the original Farmers Market in 2002, has brought "Gilmore Island" back into the spotlight. At a cost of $115 million, the Grove includes glamorous boutiques, fashionable stores, and upscale restaurants as well as an Art Deco multiplex movie theater. A vintage trolleybus tours around the new plaza and the fountain park. The clock tower and the old market stalls on the Fairfax Avenue side remain intact.

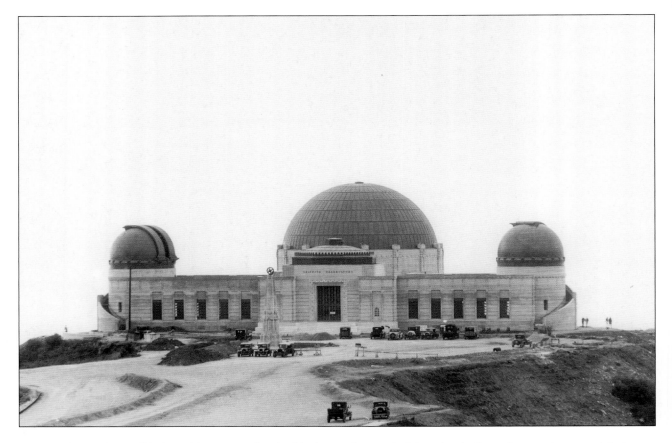

In 1896, Col. Griffith J. Griffith donated five square miles of parkland (to be named after him) to the city. Since 1935, Griffith Observatory on Mount Hollywood has been a major Los Angeles landmark. It has three distinctive large copper domes. The right dome houses the solar telescope, the left one has the Zeiss refracting telescope, and the large middle dome houses the Planetarium Theater. In the center of the main rotunda, the 240-pound brass ball of the Foucault Pendulum swings constantly while the earth turns beneath it.

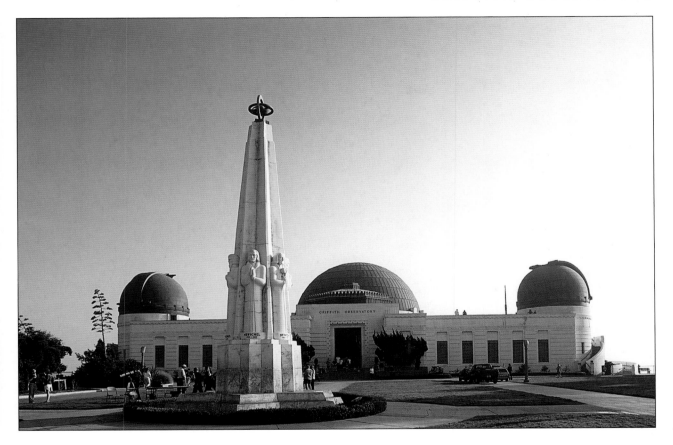

As a working observatory, the radio antenna (near the Astronomer's Monument) receives signals from weather satellites for display in the museum. The observatory has two million visitors a year, including school groups that come for the planetarium shows. Fans also flock to see where James Dean filmed *Rebel Without a Cause* and his bronze memorial bust on the west lawn. The current renovations will leave the three domes intact, with expansions dug several levels underneath the observatory. A larger research area has been built, together with a new museum, restaurant, teaching facilities, and the Leonard Nimoy Theater for films and lectures. The observatory reopened in November 2006.

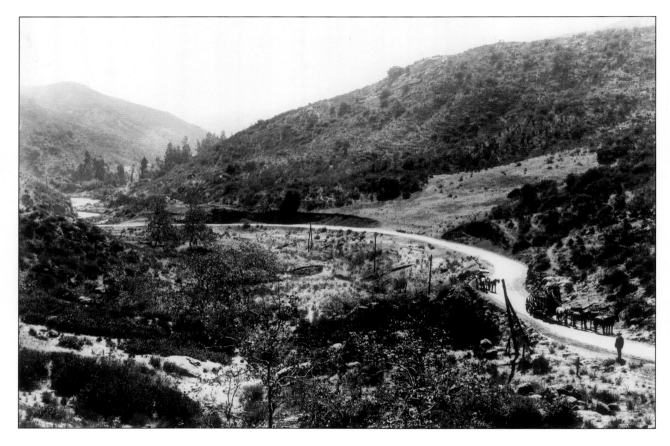

The Gabrieleno Indian word *cahuenga* means "place of the mountain." The Cahuenga Pass was originally an Indian footpath and burial ground. It was also used by the Spanish and Mexicans to drive their cattle across the mountains and was the site of several skirmishes over land use. In 1889 (when this photo was taken), it was traversed by stagecoaches and mule teams, and at the turn of the century, by cyclists. In 1926, the roadway, connecting Hollywood with the San Fernando Valley, was completed.

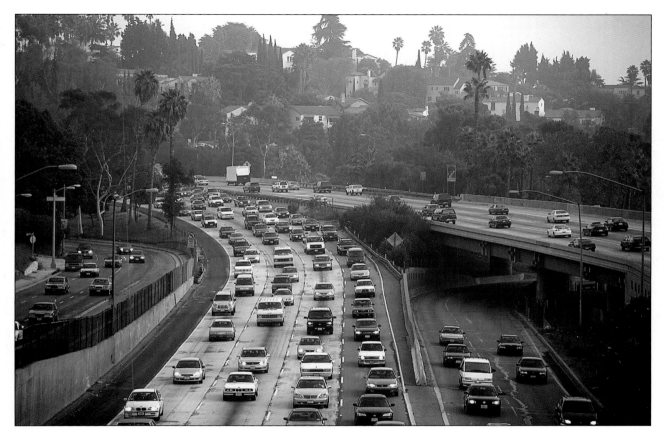

By 1915, the Pacific Electric Railway's Red Cars took passengers through the Cahuenga Pass, which was later paved for bus routes. In 1954, with an increase in traffic, this was expanded and became the route for the new Hollywood Freeway. Today, a narrow road remains on either side of the heavily used freeway. Underneath the Cahuenga Pass, a new subway system is under construction, once again linking Hollywood with the Valley.

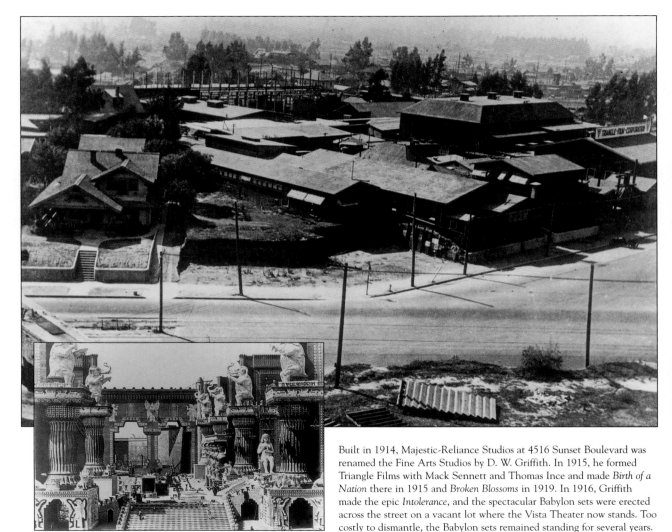

Built in 1914, Majestic-Reliance Studios at 4516 Sunset Boulevard was renamed the Fine Arts Studios by D. W. Griffith. In 1915, he formed Triangle Films with Mack Sennett and Thomas Ince and made *Birth of a Nation* there in 1915 and *Broken Blossoms* in 1919. In 1916, Griffith made the epic *Intolerance*, and the spectacular Babylon sets were erected across the street on a vacant lot where the Vista Theater now stands. Too costly to dismantle, the Babylon sets remained standing for several years.

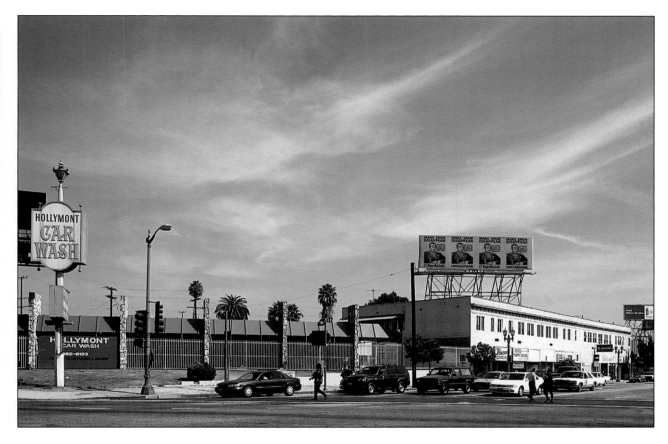

Columbia Studios took ownership of the Fine Arts Studios in the
1950s, but a fire destroyed the lot in 1960. The site now houses a car
wash and shopping center. The distinct designs from the Babylon set
of *Intolerance* have been incorporated into the new Academy Awards
Building at Hollywood and Highland. The hieroglyphics and towering
white elephants are on the archway over the stairway, and the elephant
motif is repeated on the Highland Avenue side.

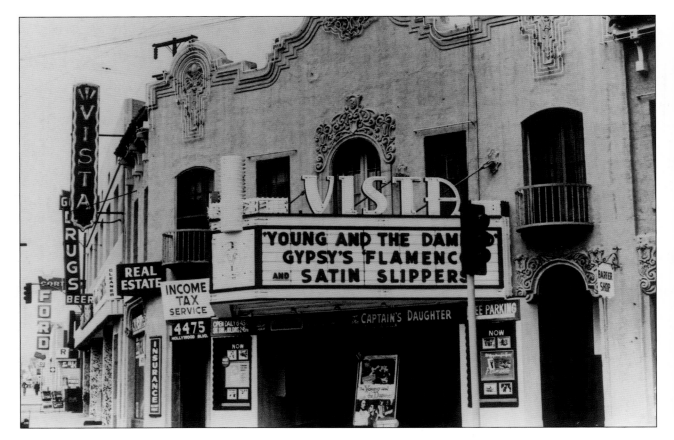

The Vista Theater stands on the site of the towering Babylon set of D. W. Griffith's 1916 film *Intolerance*. Built in 1923 as a vaudeville house, it was called "Bard's Theater" after a local showman who built four theaters, all with the lavish Egyptian interiors that were popular at the time. It was ten cents for the movie, five cents for candy, and on Sundays they had four vaudeville acts before the movie. In 1939, the Vista had over 600 seats.

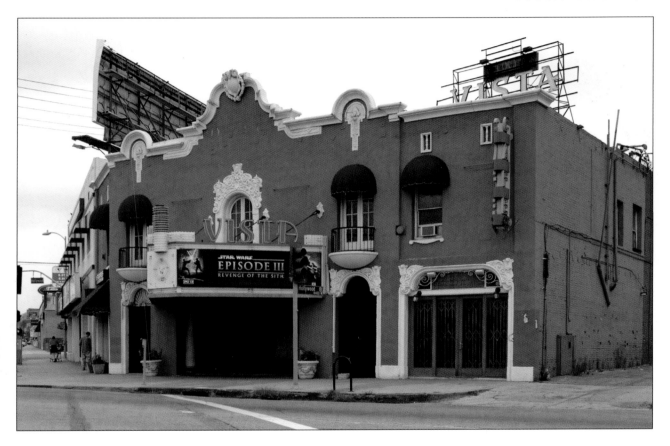

After World War II, the Vista Theater and neighborhood became run-down. In the 1970s, it ran adult movies and, later, Spanish-language films. But film enthusiasts, realizing the historical value of this bijou theater, have now carefully restored it. Carvings from the Babylon set remain inside, but today there are fewer seats, more legroom, and a revamped sound system. The Vista shows classic and first-run films and remains a local favorite.

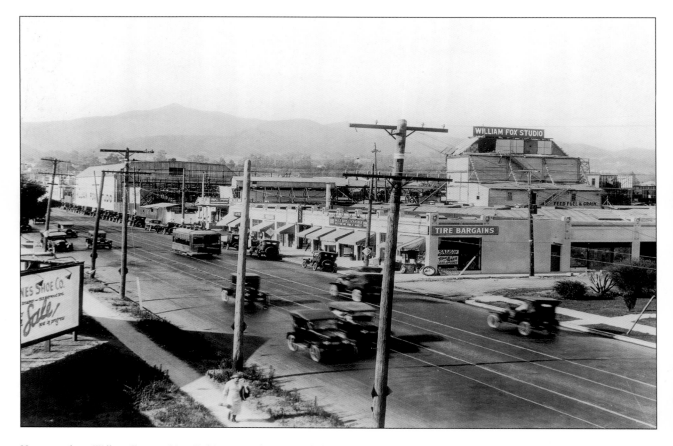

Hungarian-born William Fox quit New York's garment business and moved to Hollywood to make movies. Purchasing the Dixon Studios on Western Avenue in 1917, he then expanded his new William Fox Studios, signing stars such as Theda Bara and Tom Mix to great success.

In 1924, Fox Studios moved to its present Pico Boulevard address, formerly Tom Mix's ranch. In 1935, Fox Film Corporation merged with Darryl F. Zanuck's Twentieth Century Pictures to become Twentieth Century Fox Corporation.

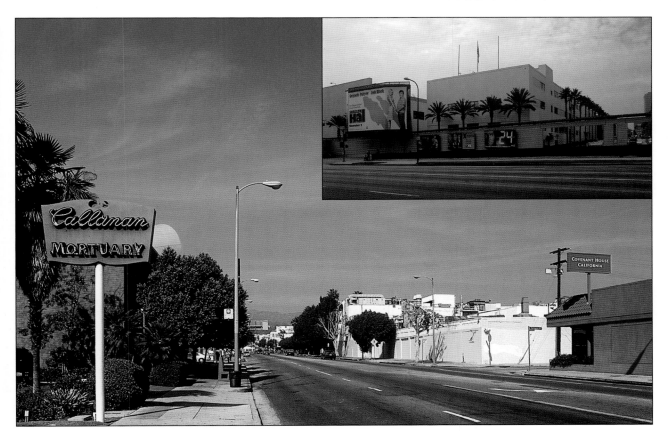

The Western Avenue Studios changed hands often and is currently owned by British Rank Organization for postproduction. William Fox died in 1952, but under Zanuck's guidance, the studio prospered with stars like Shirley Temple, Tyrone Power, and Marilyn Monroe and films such as *The Sound Of Music* and *Hello, Dolly*. In 1965, Fox sold off much of its land to the Century City Shopping Center and Entertainment Complex. Today Twentieth Century Fox Studios are at 10201 West Pico Boulevard (*see inset*).

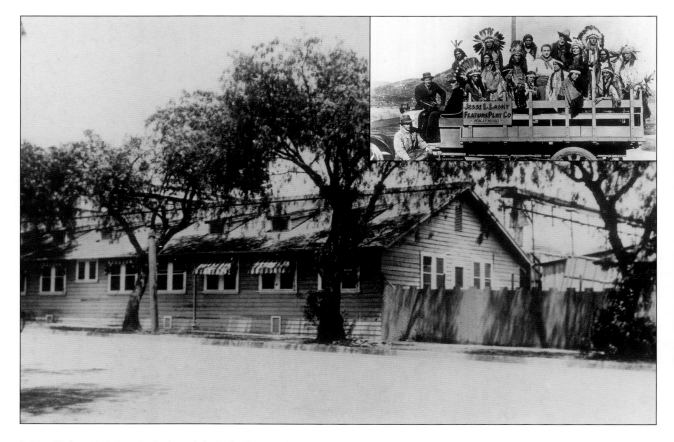

In New York in 1913, Jesse Lasky formed the Lasky Feature Play Company with Cecil B. DeMille. After finding Arizona an unsuitable place to film, they continued on to Hollywood. Lasky rented a barn on Vine above Sunset for their studio, and in 1914 their first film, *Squaw Man*, was also the first full-length film made in Hollywood. A year later, Lasky Studio owned the whole block. Triumphantly, in 1925, Lasky's Featured Play Company merged with Zukor's Famous Players Films to form the Famous Players-Lasky Corporation.

In 1926, the company moved to the huge United Studios on Marathon and Van Ness. Their old studio at Sunset and Vine was demolished and NBC Studios replaced it in 1938. Today, Washington Mutual Savings and Loan occupies the site. United Studios was renamed Paramount-Famous-Lasky in 1927 and eventually became Paramount Studios. The original "old barn" used for *The Squaw Man* was stored at Paramount for fifty years and is now part of the new museum on Highland Avenue.

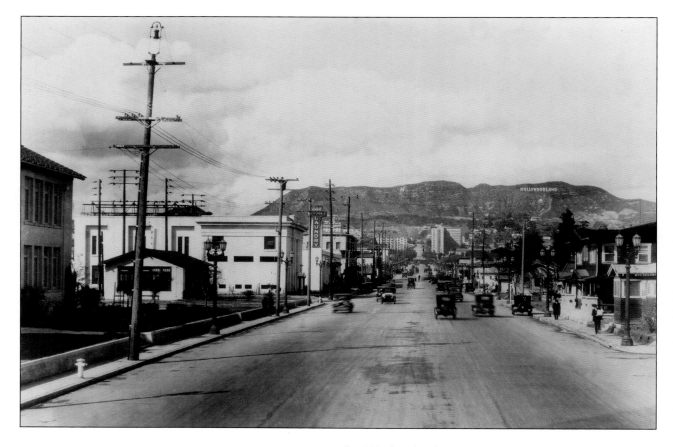

In 1925, when this photo was taken, Vine Street was lined with elegant restaurants such as the Brown Derby, Breneman's, and Al Levy's Tavern. Nightclubs like the Montmartre attracted stars such as Joan Crawford. Vine Street had beautiful speciality stores, as well as theaters that broadcast live radio shows with Jack Benny, George Burns, and others.

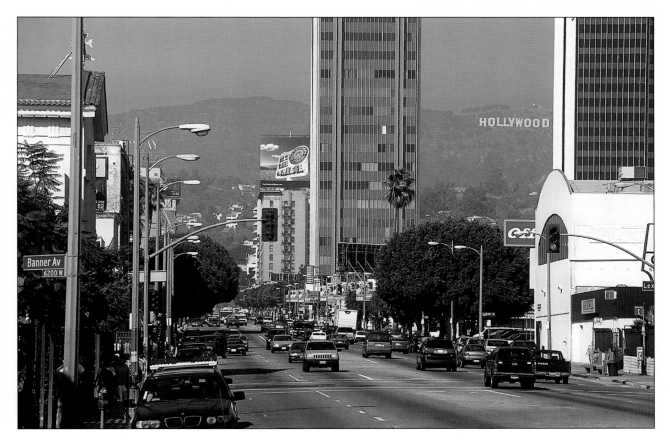

"It all changed after World War II," locals say. People did not go dancing as much, the tastes in theater changed, and "progress" led to the modernization of many old establishments. Beautiful buildings were demolished, restaurants were replaced with fast-food joints and drive-ins—which were then replaced by discount shops and thrift stores. Skyscrapers block the mountain views and the trolleys were replaced with newer, faster cars, but on a clear day, one can still see the Hollywood sign.

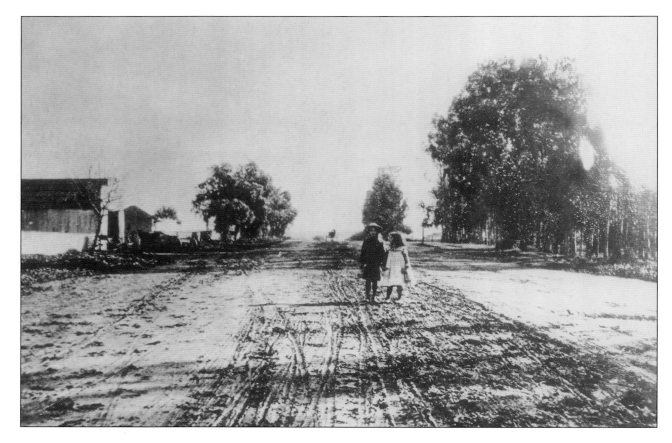

In 1905, these two young girls strolling down Sunset Boulevard could have no idea of the impact this area would have on the world. The northwest corner would become the site of Hollywood's first film studio—the New Jersey Nestor Film Company—in twenty years. In 1910, to the right, would be several small film companies, whose lack of finances led to this area being dubbed "Poverty Row." This site later became the famous Sunset-Gower Studios, home of Columbia Pictures.

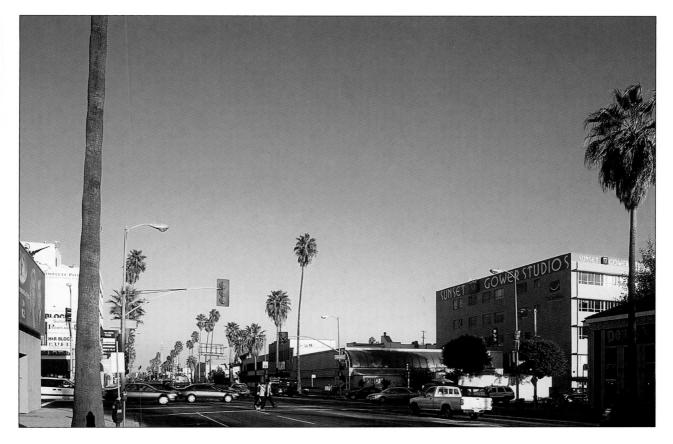

In its heyday, Columbia Studios produced such films as *It Happened One Night*, *On the Waterfront*, *The Bridge on the River Kwai*, and *Funny Girl*. After corporate restructuring in 1972, Columbia joined Warner Brothers at the Burbank Studios. In 1990, Columbia was bought by Sony and moved to the MGM lot in Culver City. Meanwhile, the renovated Sunset-Gower Independent Studios keep busy with television and film productions.

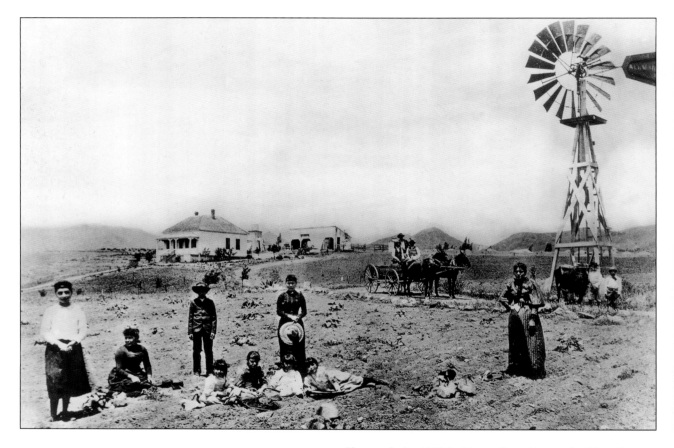

Photographed in 1896, Joe Mascarel's ranch was at Franklin and
Gower. He was mayor of Los Angeles in 1865. Mascarel was a French
sea captain who came here from Mexico in 1844. He married a Native
American woman and became a successful merchant and property
owner. Mascarel and his French partner bought valuable land in
downtown Los Angeles and, in 1871, he cofounded the Farmers and
Merchants Bank.

While Farmers and Merchants Bank lives on downtown, all signs of the Mascarel Ranch are long gone. The area of Gower Street above Hollywood Boulevard near Franklin had become a residential area, but the beautiful homes, like so many others, have been torn down to make way for new streets, apartment buildings, cheap motels, and commercial enterprises.

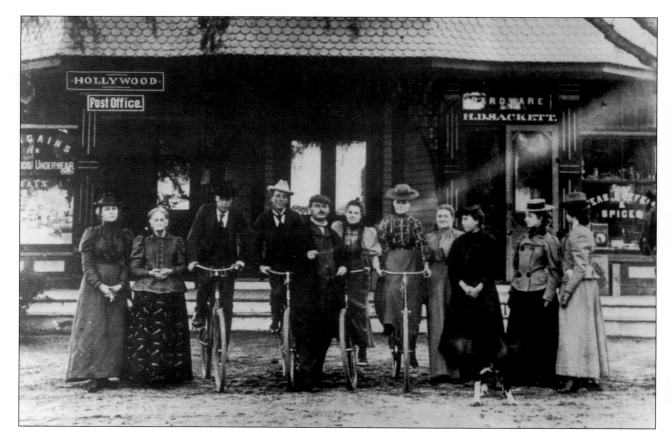

Built in 1888, the Sackett Hotel was the first inn in the Cahuenga Valley. Horace Sackett built the three-story hotel, which offered good food and accommodation. Mr. and Mrs. Sackett also opened the second general store in town, selling everything from teas, spices, and hardware to underwear. In November 1897, the first Hollywood post office opened in the Sackett Hotel. Mrs. Mamie Sackett later became the first postmistress in Hollywood.

Many of the old hotels were made of wood and frequently caught fire. As a result, there are no signs remaining today of this part of history. Hollywood and Cahuenga Boulevards later became a business area, with elegant stores and professional office buildings. Those structures have been demolished—many were made unsafe during the underground excavations for the Metro Subway that runs underneath Hollywood Boulevard.

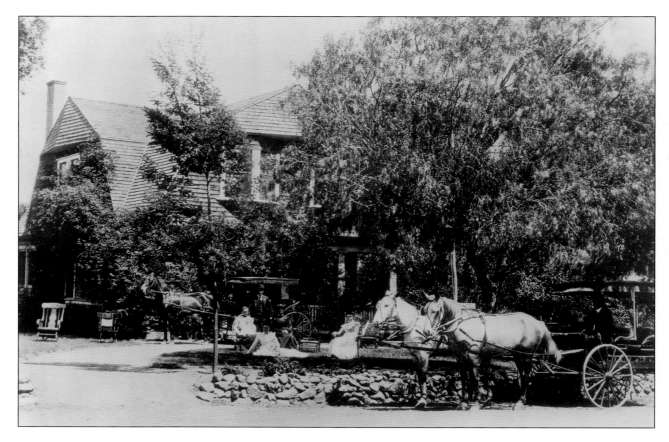

The Glen Holly Hotel, popular in the late 1890s, was built a few years after the Sackett Hotel. The Glen Holly Hotel had a country garden setting and was known for its beautiful roses. For tourists and prospective homeowners, tours of the area ran from this hotel. In 1900, when this photograph was taken, they advertised, "Pierce's Stage will drive you around the Cahuenga Valley and then back here for a Chicken Dinner— or as served—for 75 cents."

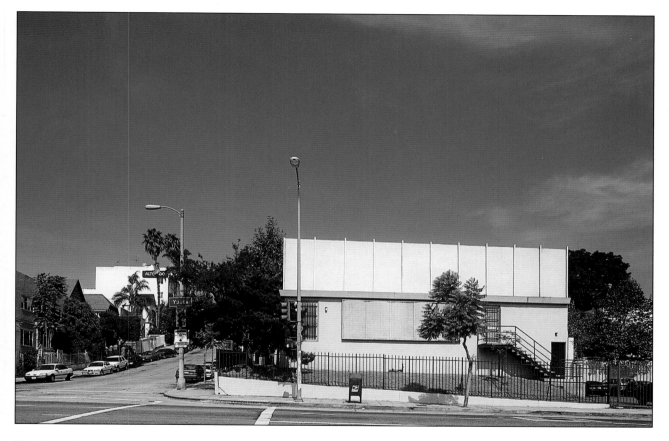

The Glen Holly Hotel had stood on what is now the corner of Yucca and Ivar. It was replaced by elegant private homes, but like so much of old Hollywood, they were torn down in the 1960s and replaced with modern apartment buildings. Although these streets had become dilapidated in the 1980s, there is currently a gentrification effort afoot. The old Knickerbocker Hotel, just a few yards away from this site, is now a retirement home.

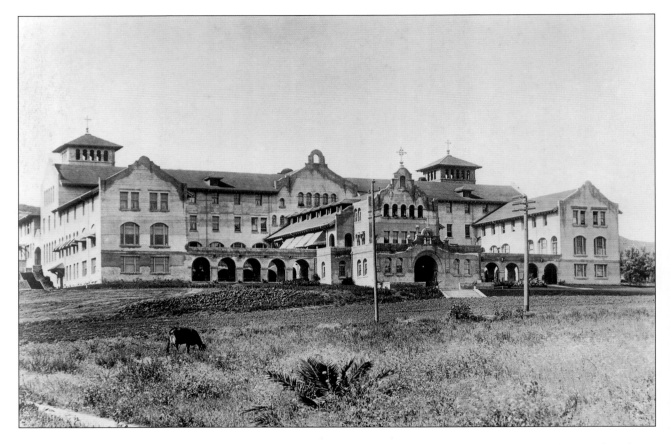

In 1906, the Sisters of the Immaculate Heart of Mary bought a fifteen-acre mustard field in the Hollywood Hills (later Western and Franklin) for $10,000. Here they founded a Moorish-style convent and girl's high school with boarding facilities, adding the college portion a decade later. By 1908, Immaculate Heart College for Girls attracted pupils from foreign countries, as well as from all over California. The first private school to confer college degrees, the college awarded its first Bachelor of Arts degrees in 1921.

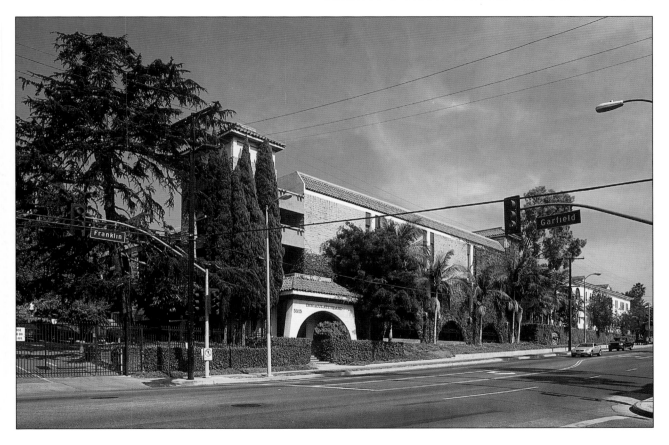

In the 1960s, the boarding school closed, and in 1980, the old college building was sold to the American Film Institute for their film school and library. This enabled Immaculate Heart to build a new gymnasium and computer room, and in 1984, a competition-size swimming pool was installed. The old convent was demolished in 1991 to provide a new playing field. Lucille Ball's daughter, Lucie Arnaz, was one of the celebrity students who attended the college.

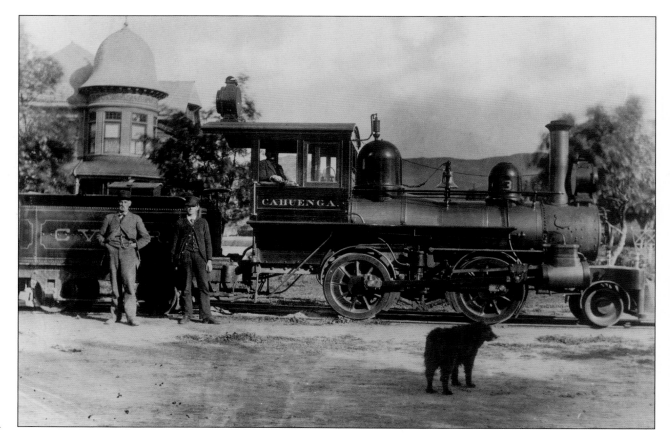

In 1887, the Los Angeles Ostrich Farm Railway Company built Hollywood's first railway, linking Dr. Sketchley's Ostrich Farm at Los Feliz with Hollywood. The Cahuenga Valley Railroad, installed in 1888, ran through the heart of the city and was called "the fast train to East Hollywood." This train is on Hollywood at Wilcox in 1893, in front of the Hurd House. The residents complained that "the engines caused great noise and frightened the horses," and so a long battle ensued.

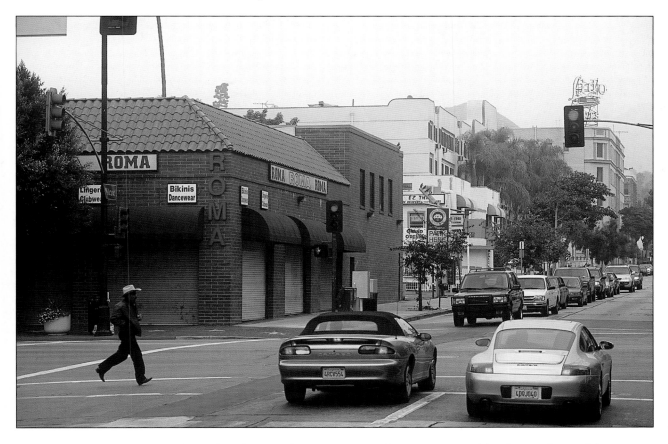

Industrialist General Moses Sherman bought the Cahuenga Valley Railroad, which later became Southern Pacific Railroad. Residents preferred horses or bicycles, but eventually warmed to the trains that took them as far as the ocean. Today, the rail tracks are gone. In the 1970s, at the encouragement of the oil, tire, and automobile companies, all remaining train tracks were replaced by roads and freeways. Today this part of Hollywood is filled with small stores and vendors offering exotic clothing and gifts.

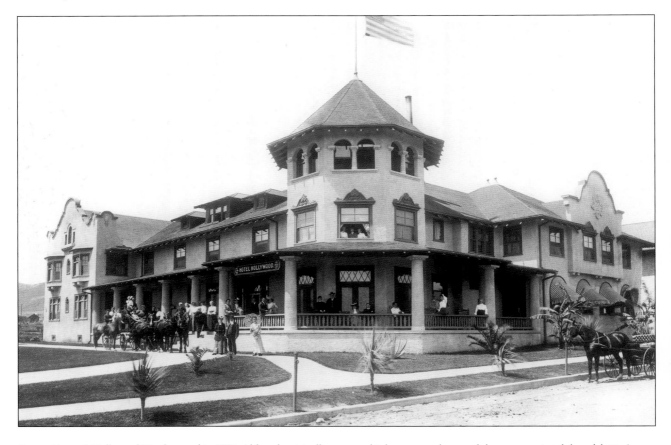

George Hoover's Hollywood Hotel opened in 1903. Although originally built for land prospectors, it was the film community that flocked to the Hollywood Hotel. Douglas Fairbanks, Lon Chaney, and Norma Shearer were among the stars who dined and danced here. Rudolph Valentino spent his honeymoon here, and the owners painted the celebrities' names in gold stars on the ceiling, a practice that would lead to a great Hollywood tradition and landmark, the Walk of Fame.

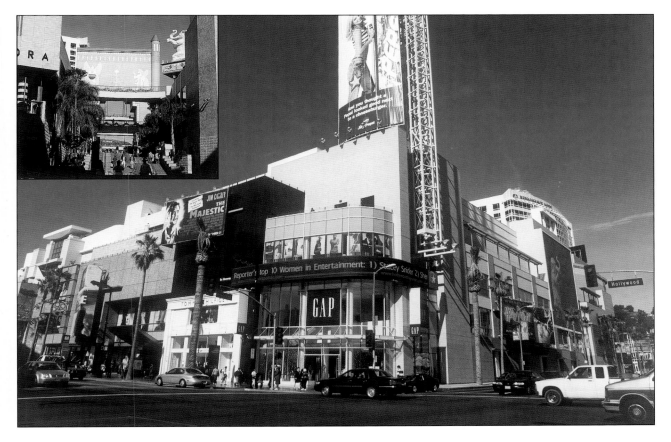

The hotel was demolished in 1956 and replaced by a bank. The star names taken from the hotel ceiling were placed on the sidewalk in front of the bank and the Walk of Fame was born. The new $615 million Hollywood and Highland Complex restores Hollywood to its former glamour with the Kodak Theatre, Debbie Reynold's Hollywood Collection, the Grand Ballroom, nightclubs, restaurants, and shops. The Babylon Court features the elephants and designs from D. W. Griffith's film *Intolerance*.

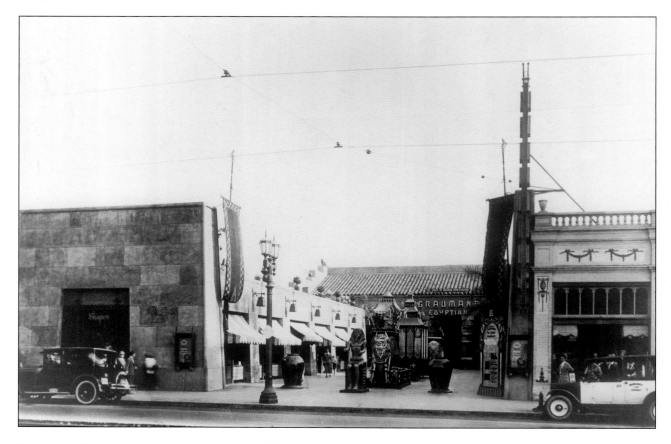

The Egyptian Theatre was the first Grauman theater in Hollywood, opening in 1922 with the premiere of Douglas Fairbanks's *Robin Hood*. The first theater to have a forecourt, with Asian shops on either side, Grauman chose film props from the current movie for display. Four massive columns marked the entry, and on the roof, an actor in an Egyptian costume marched back and forth calling out the start to each performance. For Cecil B. DeMille's 1923 *Ten Commandments* premiere, Grauman had over a hundred costumed performers on parade.

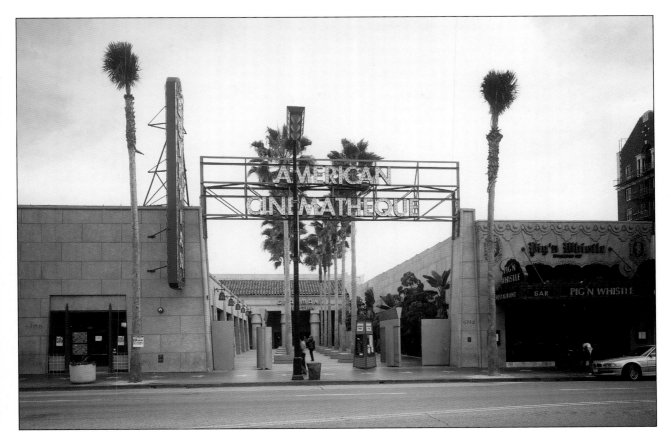

The Egyptian Theatre closed in 1992, reopening in 1998 following a $15 million refurbishment. American Cinemateque (a nonprofit arts organization) had bought it from the city for one dollar, with the provision that it be restored to its former grandeur as a movie theater and add programs on filmmaking, past and present. The historic ceilings and the 1922 theater organ were also repaired. The adjacent Pig 'n' Whistle Café (famous for its sundaes since 1927) has been lovingly restored and reopened.

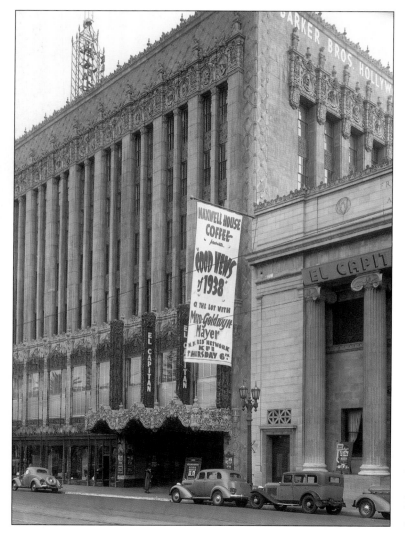

Real estate developer Charles Toberman (the "Father of Hollywood") envisioned a thriving Hollywood theater district. With Sid Grauman, he built the Egyptian, El Capitan, and Chinese Theatres. A legitimate theater, El Capitan opened on May 3, 1926 for a screening of *Charlot's Revue*, starring Jack Buchanan and Gertrude Lawrence. In the next decade, over 120 live plays were produced with such legends as Clark Gable and Joan Fontaine. El Capitan closed shortly after Orson Welles's *Citizen Kane* premiered there in 1941.

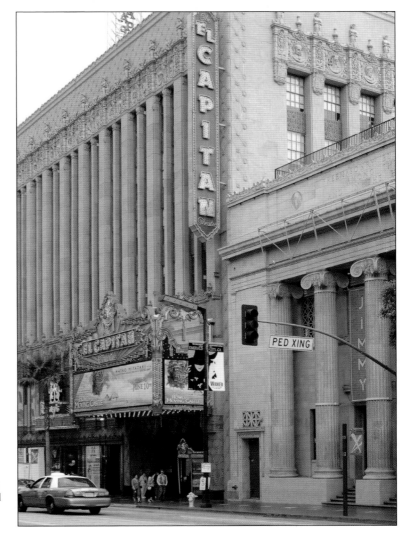

In 1942, El Capitan reopened as a cinema, the Hollywood Paramount. Although successful, after the 1960s the Paramount changed hands often. In 1989, when the Walt Disney Company joined with Pacific Theaters to restore this historical gem, they carefully returned El Capitan to its original Spanish-Colonial, East Indian splendor. Today, Disney films premiere here with live stage shows. The Masonic Temple (frequented by Charlie Chaplin, Bob Hope, and Cecil B. DeMille), now houses the Disney *Monsters, Inc.* Fun Palace.

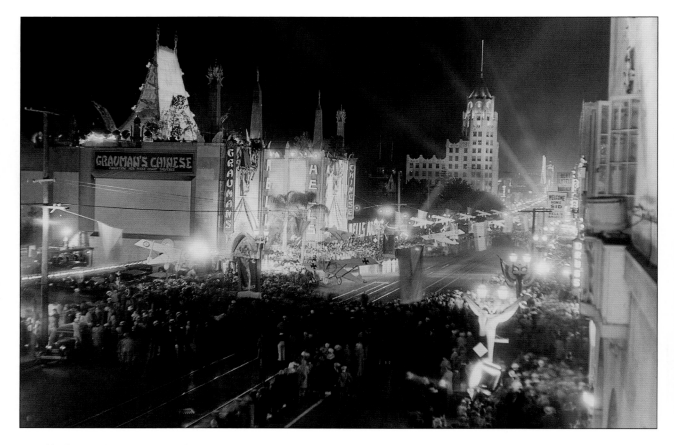

Arguably the most famous theater in the world, Grauman's Chinese Theatre was the brainchild of Sid Grauman and C. E. Toberman. They teamed together to produce a lavish and ornate theater, complete with a giant Chinese pagoda and dragons, and it opened in 1927. When Norma Talmadge accidentally stepped into wet cement on the forecourt, showman Sid Grauman had a now famous idea: footprints and handprints of the stars immortalized in the forecourt. The image above shows the 1930 premiere of "Hell's Angels" starring Jean Harlow.

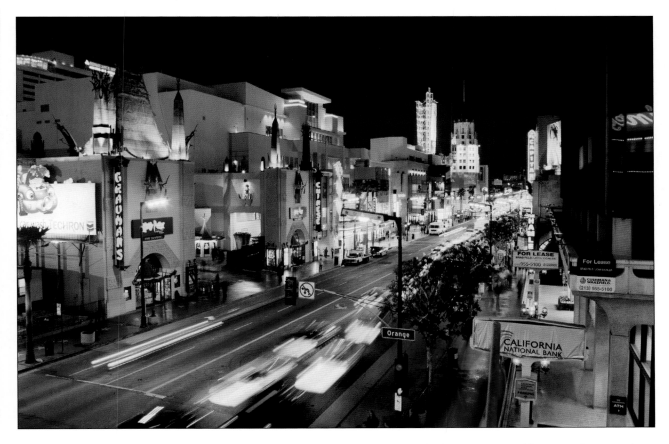

Known for its gala premieres, the Chinese Theatre had over 10,000 spectators for the 1939 opening of *The Wizard of Oz*. Renamed Mann's Chinese after Ted Mann acquired it in 1973, the theater was bought by a partnership of Warner Brothers and Paramount in 2000. They changed the name back to Grauman's and have recently renovated it, returning the theater to the way it was in 1927—though they retained the state-of-the-art sound and projection systems. It reopened with the premiere of *Harry Potter and the Sorceror's Stone*.

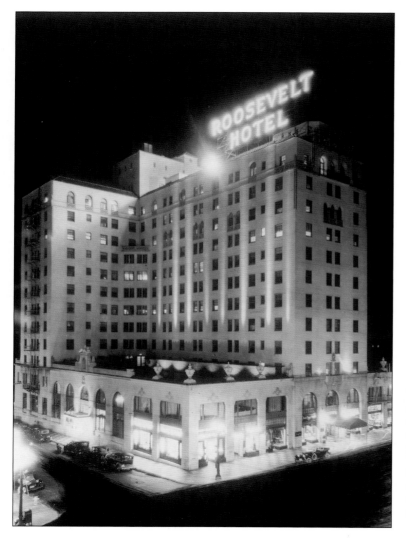

The Roosevelt Hotel was built in 1927 by a group of celebrities, including Douglas Fairbanks, Mary Pickford, and Louis B. Mayer, to house East Coast moviemakers and stars working in Hollywood. Gable and Lombard paid five dollars a night for their penthouse, Shirley Temple practiced tap dancing on the ornate tile stairs, Marilyn Monroe frequented the Cinegrill (which opened in 1936), Montgomery Clift stayed in room #928 while making *From Here to Eternity*, and the first Academy Awards ceremony was held here in 1929.

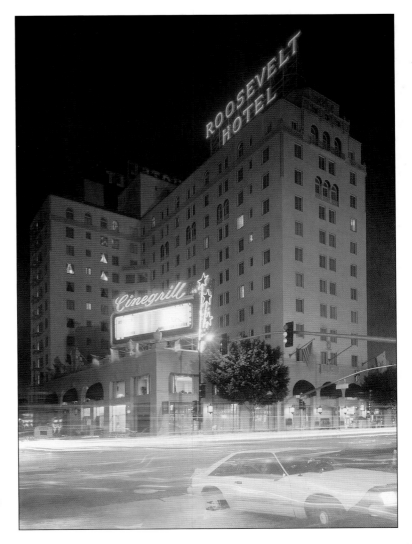

Today the spirits of both Marilyn Monroe and Montgomery Clift are said to inhabit the hotel. The Roosevelt Hotel has been featured in many films, including *Beverly Hills Cop*, *Sunset*, and *Internal Affairs*. The oldest continuously open hotel in Hollywood, the Roosevelt underwent a multimillion-dollar renovation, which included the famous Cinegrill, now a 120-seat cabaret and screening room. Hollywood's "Honorary Mayor," Johnny Grant, lives in the penthouse. Grant is host to the Walk of Fame Star Ceremonies.

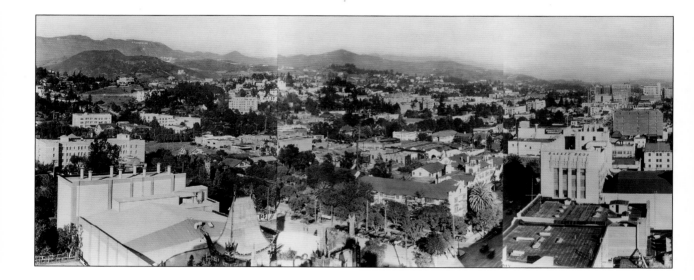

Henry Wilcox's dream of a city of Hollywood was blossoming in the 1930s, when this photo was taken. The orange groves and bean fields of the Cahuenga Valley was now a thriving metropolis. The pagoda from Sid Grauman's Chinese Theatre was already a familiar sight and Prospect became Hollywood Boulevard. The lovely mansions of the stars and studio bosses dotted the landscape. Across the rooftops, the most famous landmark of all, the Hollywoodland sign, gleamed in the California sunshine.

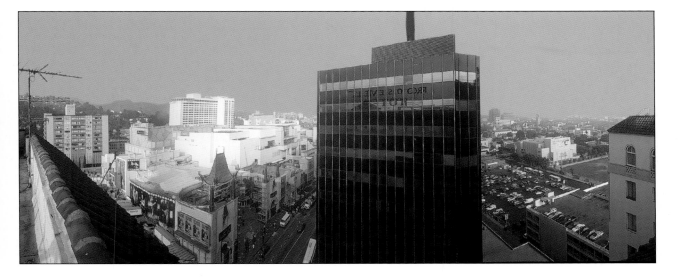

Hollywood now attracts visitors from around the world. New buildings are sprouting up across the skyline, while the older buildings are getting a face-lift. Grauman's Chinese Theatre is still a standout and the Hollywood High School athletic field still bears the insignia of *The Sheik*. Television antennae crowd the roof of the elegant Roosevelt Hotel, and the infamous smog clouds the horizon. Today the smog is so heavy that it's often difficult to make out the world-famous Hollywood sign.

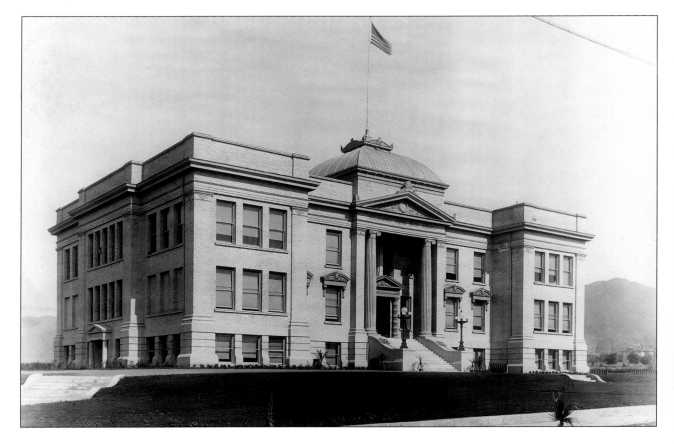

The Hollywood Union High School was built in 1904 on the corner of Sunset Boulevard and Highland, at a time when students tethered their horses on the athletic field. Children of wealthy studio bosses and movie stars were educated at Hollywood High School, which was rebuilt in the 1930s. Mickey Rooney, Judy Garland, Jason Robards, and Carol Burnett went here, but it was Lana Turner who was discovered when she skipped class and went to the Top Hat Malt Shop across the street.

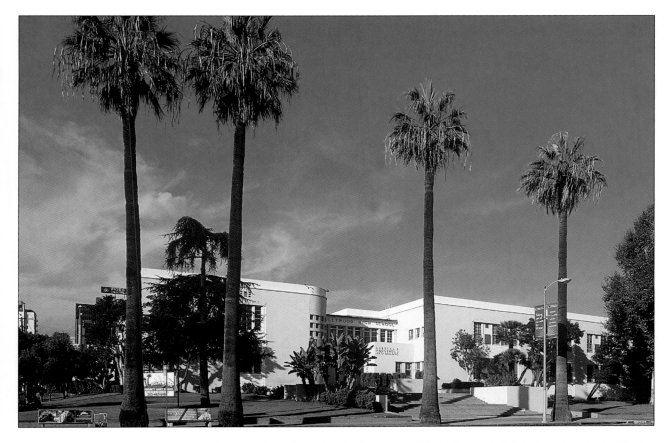

The Top Hat is gone, as well as the gas station that replaced it. Hollywood High School is still here, with its Alumni Museum, containing photos and memorabilia of the famous former students. The tribute to silent movie star Rudolph Valentino (the mural of *The Sheik*, which overlooks the athletic field) survives, and the Hollywood High School marching band still leads the Hollywood Christmas parade. In the 1960s, movie folk moved west to Beverly Hills and Malibu, and the student body has now become a colorful mixture of cultures.

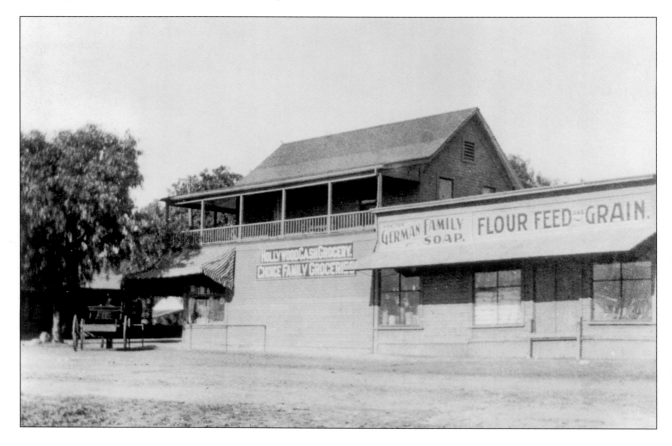

Built in 1886, the Hollywood Cash Grocery, the first permanent market and general merchandise store in Hollywood, was located on the northeast corner of Sunset and Cahuenga. Owner Alfred Watts hired a deliveryman who also picked up customers' mail on his route, then mailed it at the Prospect Park Post Office. Finally, the government stopped him from "robbing" the local post office of business. Alfred Watts then bought another store on Edgemont Street.

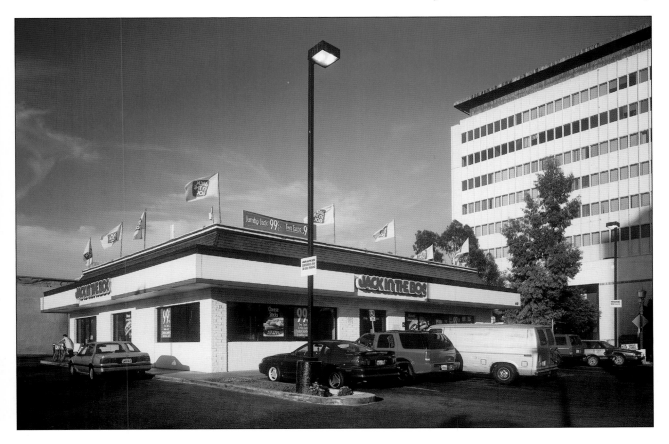

The days of such personal customer service seem to have vanished. This part of Hollywood no longer has the old mom-and-pop general stores; instead, many strip malls with chain stores have sprung up, each nearly indistinguishable from the next. This corner is now home to a Jack in the Box fast-food restaurant.

In 1917, Charlie Chaplin built Chaplin Studios in English Tudor style. Chaplin, Douglas Fairbanks, and D. W. Griffith joined forces in 1919 to form United Artists in order to distribute their movies. Chaplin shot *Gold Rush* in 1925, *City Lights* in 1931, and many others. After he left these studios in 1953, CBS filmed several television series there, including *Superman* and *Perry Mason*.

For many years, the old Chaplin Studios were owned by A&M Records. As well as owner Herb Alpert's own Tijuana Brass hits, other contract recording artists included the Bee Gees, Quincy Jones, and Janet Jackson. In 1985, a group of pop and rock stars recorded the song "We are the World" in these studios. Jim Henson Productions currently owns the studios, and Kermit the Frog, dressed in Chaplin's *Little Tramp* outfit, is perched on the studio roof over the main gate.

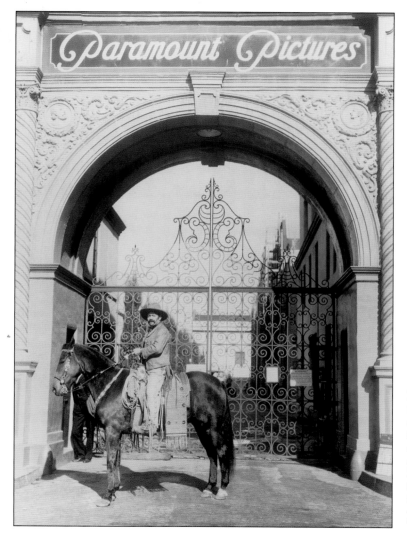

Paramount is the only major film studio still operating in Hollywood. Famous Player-Lasky Corporation took over the 1917-built United Studios in 1926 and renamed it Paramount. Some of the biggest names in show business, including Mae West, W. C. Fields, and the Marx Brothers, filmed here. In 1957, Desilu Productions (of the *I Love Lucy* series) took over RKO Studios on Gower, which eventually became part of the Paramount lot. The Bronson Gate, shown here, was featured in *Sunset Boulevard*, which starred William Holden and Gloria Swanson.

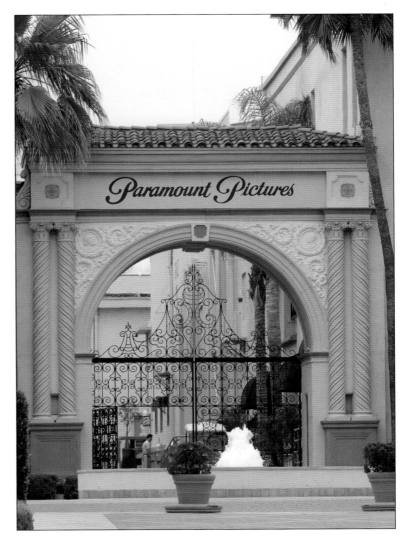

In 1966, Paramount was taken over by Gulf and Western, which also absorbed Desilu Productions. Paramount Films then produced *Rear Window*, *Breakfast at Tiffany's*, and later, *The Godfather* trilogy. Paramount Television began in 1967 with series such as *Gunsmoke* and *Happy Days*. Movies such as *Mission Impossible*, *Forrest Gump*, *Braveheart*, and *The Talented Mr. Ripley* are among some of Paramount's more recent successes. Viacom bought the studio in 1994 for $10 billion.

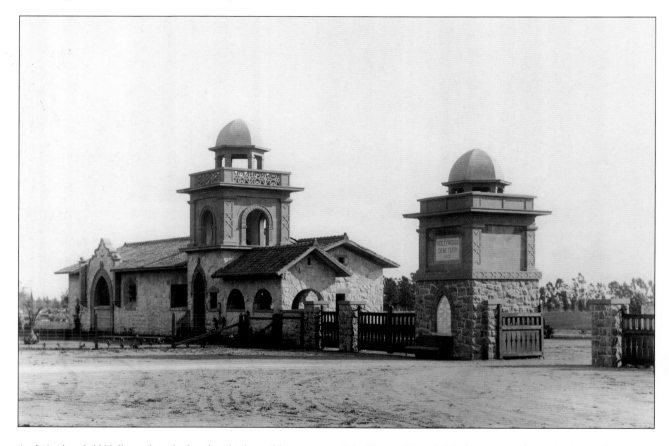

A who's who of old Hollywood can be found in this beautiful cemetery. When Rudolph Valentino died in 1926 at the age of thirty-one, ten thousand people came to pay their respects. Mausoleums and elegant headstones in memory of stars such as Peter Finch, Jayne Mansfield, John Huston, Edward G. Robinson, Douglas Fairbanks, Cecil B. DeMille, Tyrone Power, Harrison Gray Otis, and Griffith J. Griffith are found here. Established in 1899, the Hollywood Cemetery at 6000 Santa Monica Boulevard has been renamed Hollywood Forever.

Like many of the "residents," this picturesque cemetery has been featured in several movies and TV shows, including *Hot Shots*, *Charmed*, and *L.A. Story*. Actress Joan Hackett still makes people smile—her gravestone reads: "Go away, I'm sleeping." The ghost of actor Clifton Webb is said to haunt his mausoleum in the park. Originally a hundred-acre park, the south forty acres are now occupied by Paramount Studios, and from the gates of Hollywood Forever, one can see the Hollywood sign.

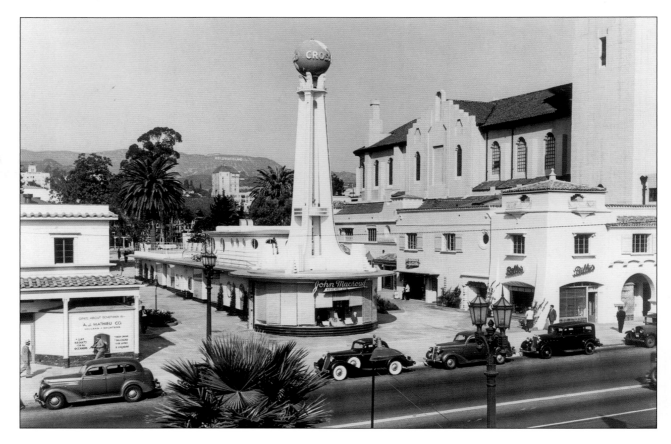

Once called "L.A.'s first modern shopping mall," Crossroads of the World opened in 1936 on Sunset Boulevard, near Las Palmas. The unique center building resembles a ship, complete with portholes and decks, along with a thirty-foot tower topped by a revolving world globe.

The bungalows surrounding this are a mixture of Italian, Spanish, French, and New England designs from architect Robert V. Derrah. This quaint pedestrian precinct with stylish boutiques was very popular in the 1930s and '40s.

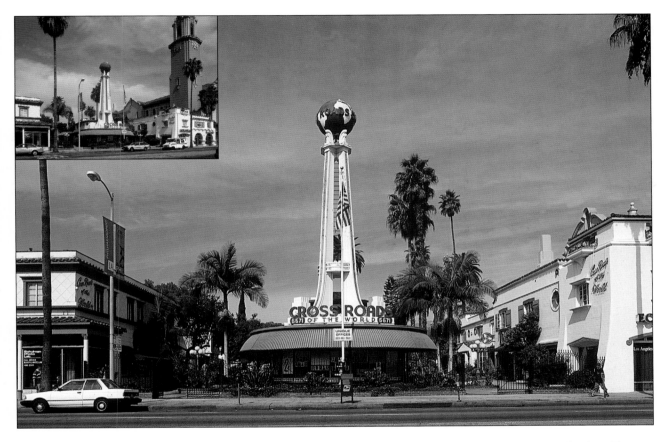

The shops in Crossroads of the World have been replaced by small businesses and talent agencies. The Hollywood Art Affair is held here each September. Crossroads has been spotlighted in *Indecent Proposal* and *L.A. Confidential*, and Danny DeVito had his office here. The small lighthouse is still in the rear, and the Church of the Blessed Sacrament (*inset*) is next door.

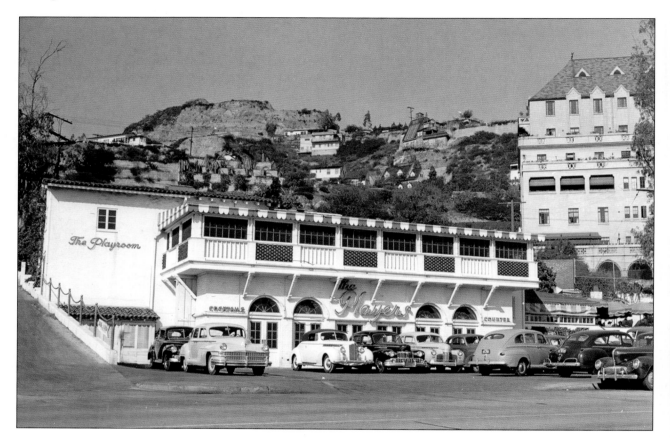

Preston Sturges, famed director of *Sullivan's Travels* and *The Palm Beach Story*, became Hollywood's most eccentric nightclub owner when he opened the Players Club in 1940 on Sunset Strip. Sturges welcomed show-business friends, such as Humphrey Bogart, Mario Lanza, Barbara Stanwyck, Orson Welles, and Howard Hughes, to his extravagant three-story club that included a barbershop, dinner theater, dance floor, and, later, a hamburger stand. Towering over it was the elegant Norman-style castle Chateau Marmont, the hideout of Greta Garbo and Marilyn Monroe.

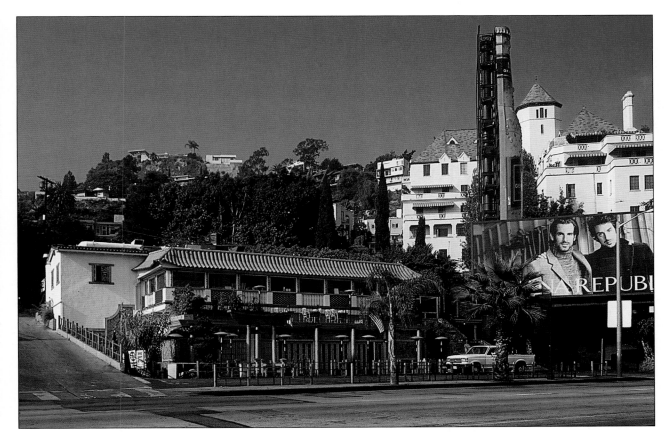

Sturges lost the Players Club to creditors in 1953. The Imperial Gardens restaurant, a rambling Japanese teahouse, replaced it, becoming another Hollywood favorite. In the 1980s, the ultrachic Roxbury took over, a hot spot for awards parties. In 2000, it was again a Japanese restaurant—now the Myagi. Meanwhile, the gothic Chateau Marmont remains unchanged. Previously home to Boris Karloff, Jean Harlow, and Billy Wilder, the Marmont gained notoriety when John Belushi died on the premises. Robert De Niro and Mick Jagger are among the more recent guests.

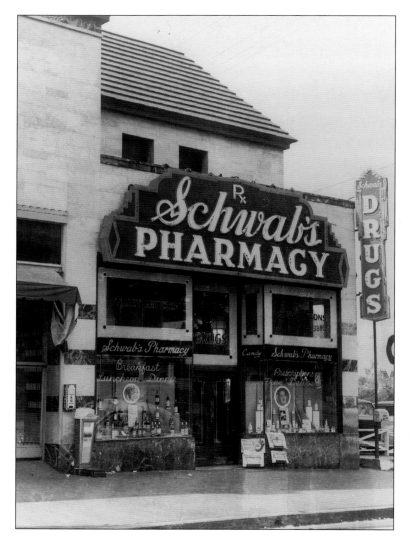

Left: Despite the stories, Lana Turner was not discovered at Schwab's Pharmacy on Sunset and Crescent Heights, but Marlene Dietrich, the Marx Brothers, and Charles Laughton were regulars. In 1939, Harold Arlen wrote "Somewhere Over the Rainbow" in a booth at Schwab's, William Holden hung out here in *Sunset Boulevard*, and Brigitte Bardot bought European toilet paper here. This was not just an ordinary drugstore—Schwab's sold top-quality cosmetics and the best ice-cream sodas and attracted the likes of James Dean and Dick Powell.

Right: Right up until it closed in 1986, agents, managers, and talent scouts discussed business in Schwab's booths. Shelly Winters held court every morning, and Cher, Linda Ronstadt, and Sally Kellerman were regulars. Sadly, Schwab's was torn down in 1988. Today the Virgin megastore sits there, part of a complex with movie theaters, stores, and restaurants. A new Schwab's Restaurant has been opened on Vine Street just north of Sunset Boulevard in the Sunset & Vine complex.

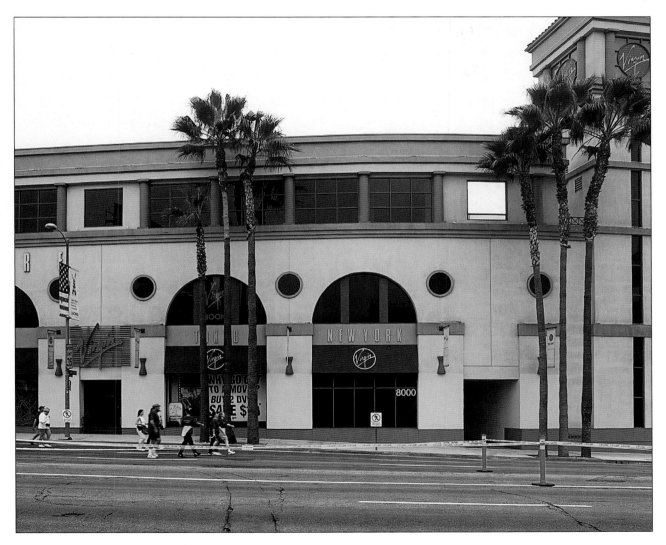

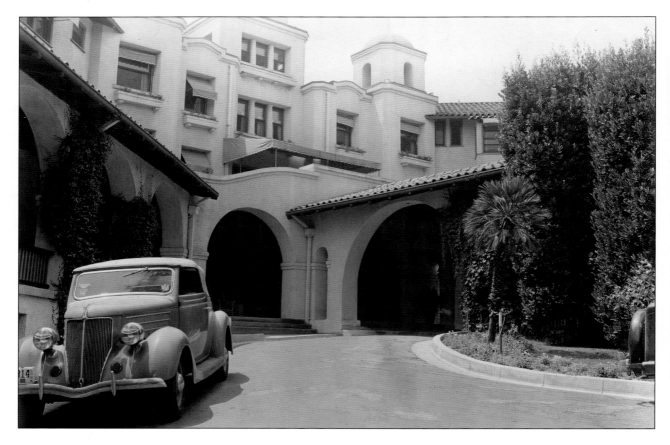

The Beverly Hills Hotel was built in 1912 by developer Burton Green on twelve acres of farmland and named after President Taft's Massachusetts Beverly Farm. Stars John Barrymore, W. C. Fields, Will Rogers, and Charlie Chaplin were early visitors to the restaurants, especially the Polo Lounge. In the 1940s, it was repainted pink and green, resulting in the nickname "the Pink Palace." Howard Hughes rented bungalows there for thirty years and Johnny Weissmuller, Joan Crawford, and Katharine Hepburn swam in their famous pool.

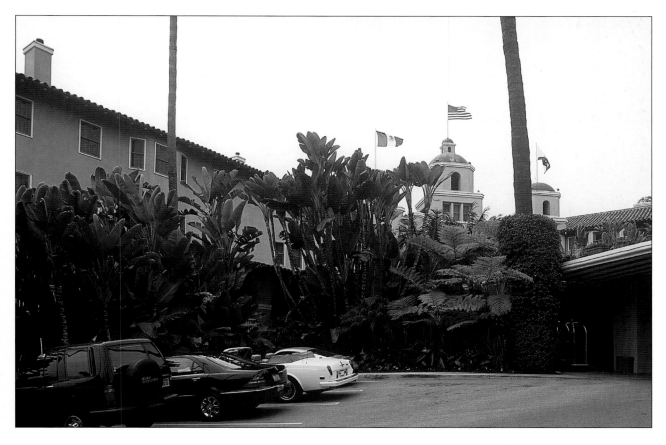

Previously a favorite with stars like Elizabeth Taylor, Frank Sinatra, Spencer Tracy, and John Lennon, the infamous Polo Lounge is still a popular meeting place for stars, Hollywood big shots, and post-award show parties. The Beverly Hills Hotel (which was once owned by Irene Dunne and Loretta Young) was bought in 1987 by the Sultan of Brunei for $187 million, and another $100 million was spent on a complete renovation in 1995.

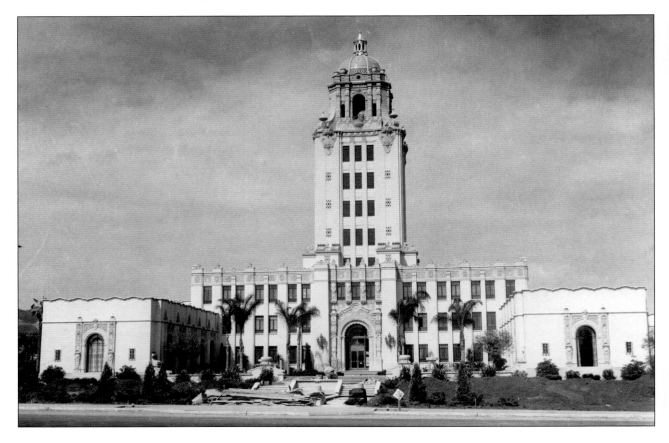

In 1906, Burton Green formed the Rodeo Land and Water Company and planned a new luxurious city, calling it Beverly Hills. It had previously been just a small train stop, called Morocco, on the route through the bean field down to the ocean. Later the land was sold for oil development. In 1919, Mary Pickford and Douglas Fairbanks built their famous home, Pickfair, and launched the migration of motion-picture people to the area. City Hall, as seen here, was built in 1931 in a bean field.

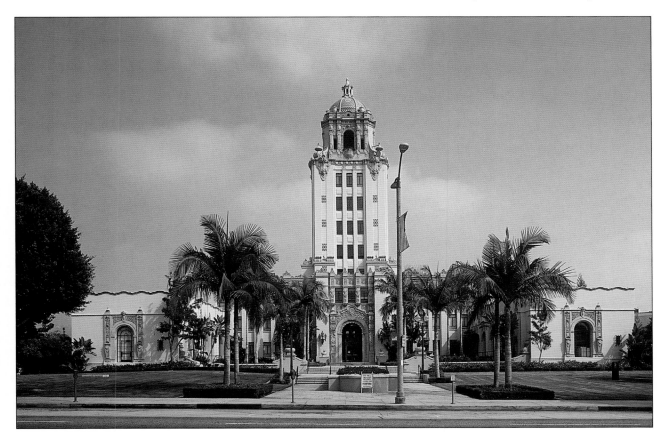

Carefully planned, the city has strict zoning laws and no slums. Today Elizabeth Taylor still lives in Beverly Hills, as do Kirk Douglas, Peter Falk, and numerous other stars. The Baroque-style city hall is featured in *Beverly Hills Cop* and its sequels. The Beverly Hills Civic Center, designed by Charles Moore in 1988, links the new library and the police and fire departments with the historic Spanish-style city hall at 455 North Rexford Drive. It was newly restored in 1992.

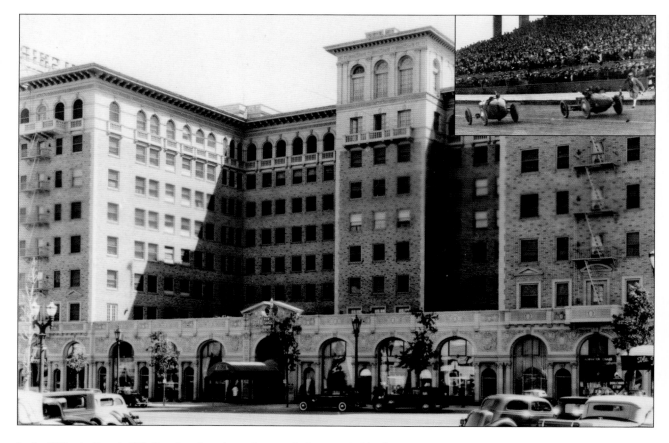

In the 1920s, the Beverly Hills Speedway (inset) was always packed with spectators, including celebrities like Wallace Beery, Charlie Chaplin, and Tom Mix. The autodrome closed in 1924 when some of the land (between Wilshire Boulevard to Pico, from Beverly Drive to Lasky) was needed to build the swank Beverly Wilshire Hotel. Built in 1927 by the Courtright family, the elegant hotel was an immediate success. Over the years, Dashiell Hammett wrote *The Thin Man* at the Wilshire, Cary Grant and Elvis Presley were residents, and Steve McQueen kept his motorcycles on site.

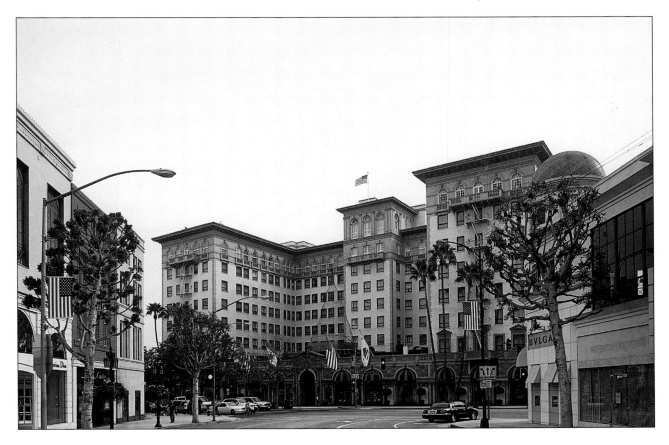

The hotel is where Rodeo Drive now meets Wilshire. John Lennon once stayed here, and Warren Beatty rented the penthouse. Michael Caine and Anthony Hopkins, as well as many other stars, politicians, and royalty are frequent visitors. Julia Roberts and Richard Gere stayed here in *Pretty Woman*—as did Eddie Murphy in *Beverly Hills Cop*. Hernando Courtright sold the hotel in 1985 when it became the Regent Beverly Wilshire Hotel. It is now part of the Four Seasons Hotels and Resorts and underwent a $35 million renovation in 1998.

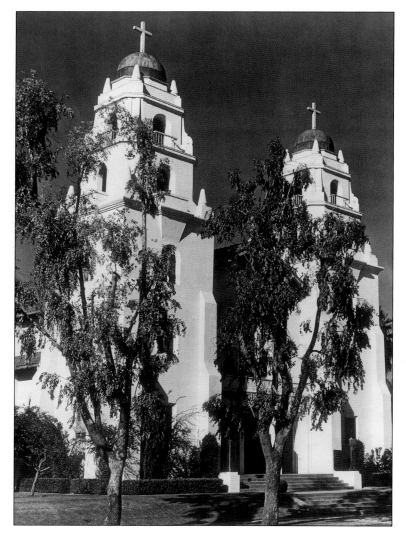

It's hard to believe that this beautiful edifice started out as a wooden hut. The congregation grew, and with generous donations, the Church of the Good Shepherd was built on Santa Monica Boulevard in 1923. Early parishioners included Rudolph Valentino, whose 1926 funeral was held here. The funeral in the 1954 Judy Garland film *A Star is Born* was filmed here. It was also popular for movie-star weddings—Loretta Young got married at Good Shepherd, as did Elizabeth Taylor in 1950.

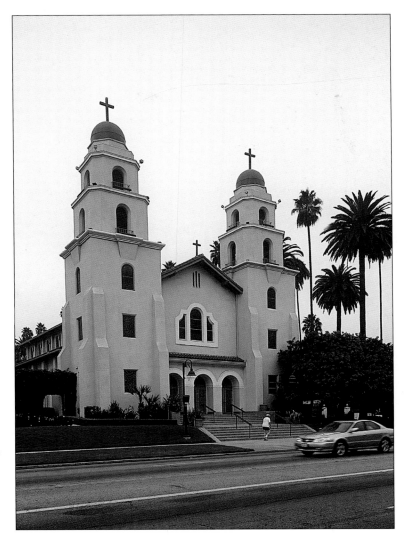

Today this beautiful church seems untouched by time. In 1995, Merv Griffin and Nancy Reagan attended Eva Gabor's funeral here, but the world was watching when the funeral of Frank Sinatra took place in 1998. Stars in attendance included Gregory Peck, Sidney Poitier, Jerry Lewis, Jack Lemmon, Liza Minnelli, Kirk Douglas, and Debbie Reynolds.

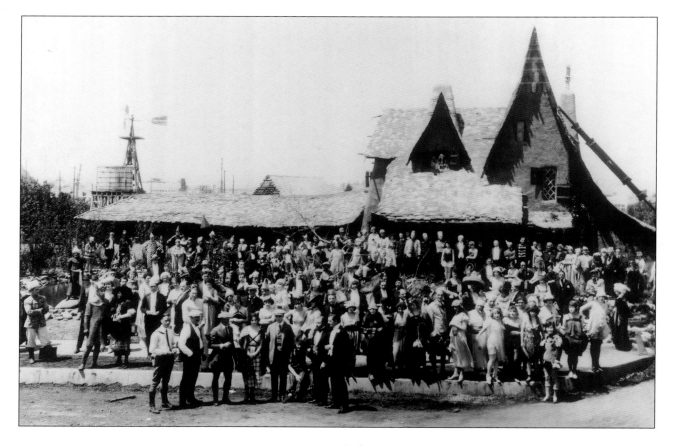

Built as a film set in Culver City in 1920, this whimsical house was used as the Willat Studios' administration building. The designer was Harry C. Oliver, who won an Oscar for the film *Seventh Heaven* in the 1920s. The Witch's House was in several silent movies during the 1920s, when it was called the "Storybook House." In 1926, the Witch's House was moved to Beverly Hills because of traffic problems caused by gawkers.

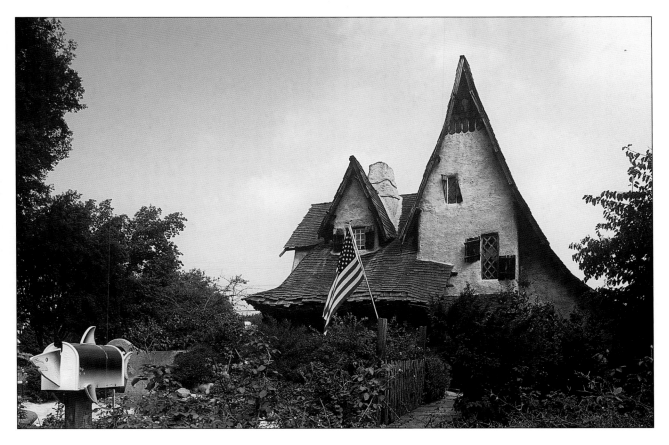

In the 1960s, the house was featured in the Rod Steiger film *The Loved One*, and more recently in *Clueless* starring Alicia Silverstone. The previous tenant would thrill the local children on Halloween, when, in a witch's hat, she would come outside and sweep her front yard, where a sign read "Witch's Landing." In 1998, real estate agent Michael Libow bought the Witch's House for $1.3 million and is restoring the roof, the three bedrooms, the loft, and the moat.

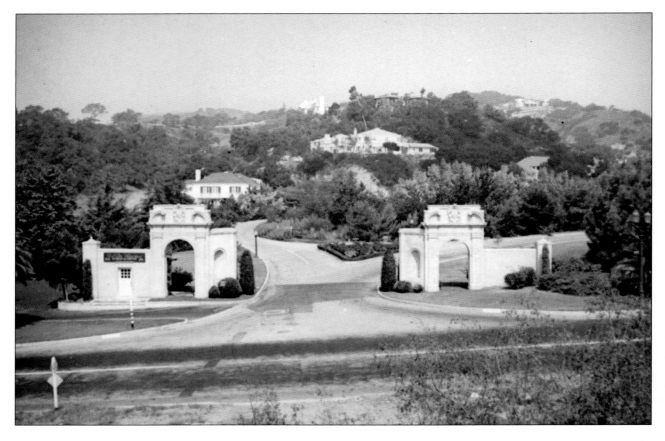

Founded in the 1920s by oil millionaire turned developer Alphonso Bell, the residential area of Bel Air hides behind magnificent Spanish gates on Sunset Boulevard near UCLA. Equally hidden down the winding roads is the famous Bel Air Hotel. A perfect hiding place for the rich and famous, this picturesque 1922-built, mission-style hotel was used by the Rockefellers and Kennedys, and Howard Hughes made business deals in the bar. Privacy-seeking stars, such as Greta Garbo, Marion Davies, Gary Cooper, Audrey Hepburn, Grace Kelly, and Sophia Loren, found solace on the leafy grounds.

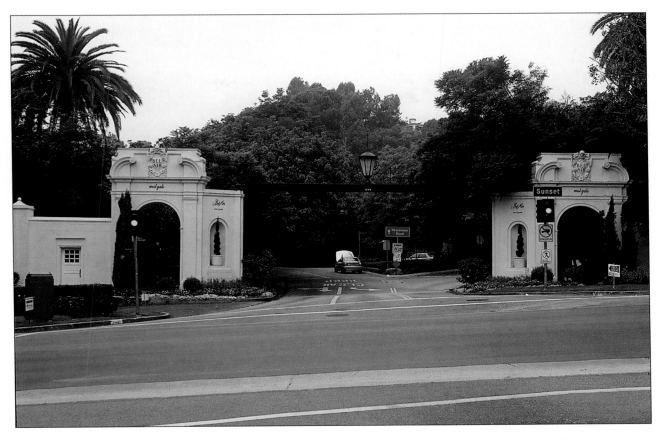

Bel Air is still an enclave of opulent homes that seem more like palaces, with servants' quarters, stables, guesthouses, tennis courts, and spacious gardens. No shops are allowed within the hallowed Bel Air gates—the Bel Air Hotel is the only commercial property permitted. The former residence of the *Beverly Hillbillies* is here, and Johnny Carson, MGM mogul Kirk Kerkorian, and Elizabeth Taylor have called it their home.

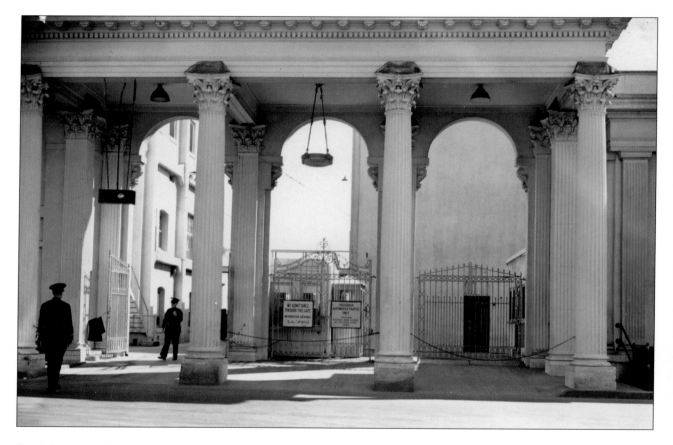

Founded in 1924 under Louis B. Mayer's guidance, Metro Goldwyn Mayer Studios was best known for musicals such as *The Wizard of Oz*, *Singin' in the Rain*, and all the Fred Astaire–Ginger Rogers films. MGM also made the *Andy Hardy* series, *The Thin Man*, *National Velvet*, and *Gone With the Wind*. MGM's stable of stars included Judy Garland, Mickey Rooney, Elizabeth Taylor, Gene Kelly, and Spencer Tracy. This 1915 classic colonnade was the original main gate on Washington Boulevard in Culver City.

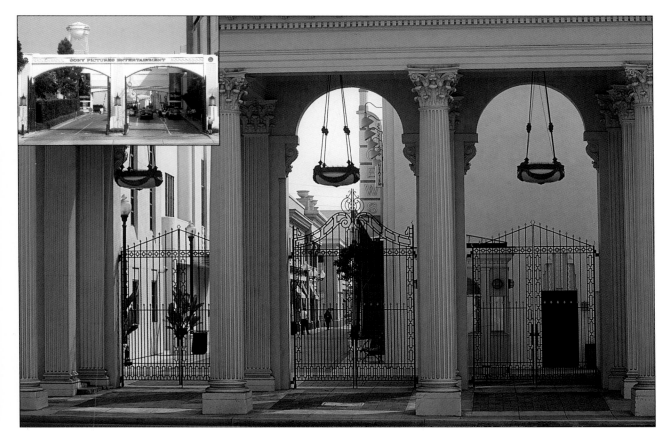

MGM sold the studios to Lorimar Television in 1980. Subsequent owners included Kirk Kerkorian and Ted Turner. Owned by Sony Entertainment since 1990, the studios' tenants, Columbia TriStar Films, have produced films such as *A Few Good Men*, *First Knight*, and *Charlie's* *Angels*. MGM corporate headquarters moved to Santa Monica until they built their own offices in Century City. Coming full circle, MGM was then bought by Sony Pictures and is now back on the original studio lot in Culver City, but the Sony Pictures name is still on top.

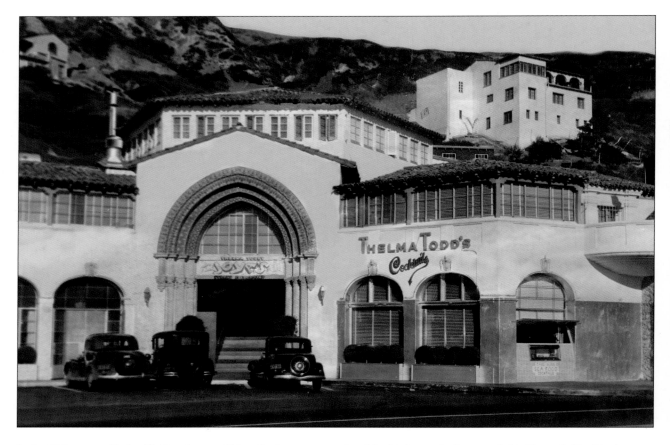

In the 1930s, actress Thelma Todd made several Marx Brothers comedies, including *Horse Feathers* and *Monkey Business*. She also ran Thelma Todd's Café, overlooking the ocean at 17575 Pacific Coast Highway between Malibu and Pacific Palisades. In 1935, she was found dead in her car in the garage behind her café. The bloody scene suggested murder, yet the death was ruled "accidental suicide." A cover-up was suspected, but the mystery was never solved. The Chez Roland Beach Club later took over through 1950.

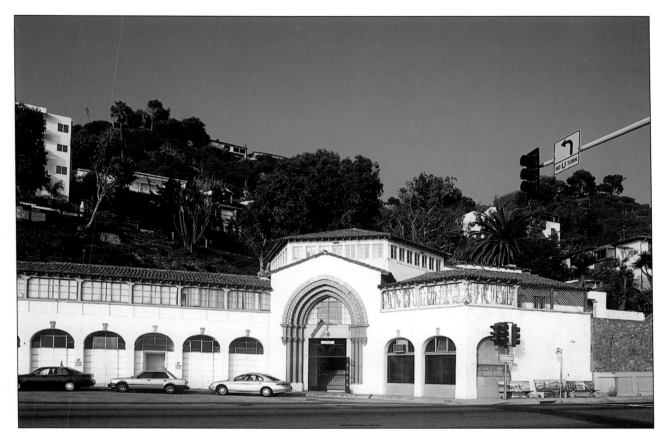

After years of neglect, the Art Deco building was bought by Paulist Productions in 1964. Founded by Father Ellwood Kieser, and dedicated to communicating spiritual values in the media, they have attracted some of the finest actors and directors including Martin Sheen, Ally Sheedy, and Ted Danson. Paulist Productions have won five Emmy Awards for their Insight television series. Employees in the production offices claim to have seen Thelma Todd's ghost on the stairs and smelled exhaust fumes where her garage was above the café.

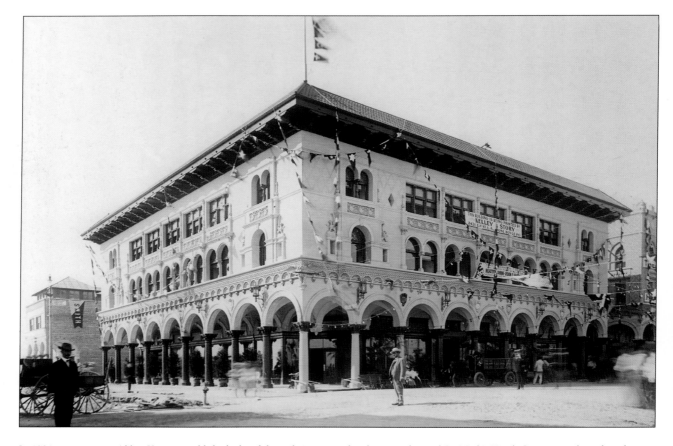

In 1904, entrepreneur Abbot Kinney established a beachfront theme park called "Venice of America." Architect Norman E. March emulated Venice, Italy, when designing this new business area, which drew crowds to the ocean. On July 4, 1905, Kinney invited thousands of potential buyers to Venice's grand opening, and the centerpiece was the elegant, columned St. Mark's Hotel. Catering to the rich and famous, St. Mark's welcomed stars such as Charlie Chaplin, Sarah Bernhardt, Theda Bara, and Douglas Fairbanks, who also enjoyed the Venice Casino and Dance Pavilion.

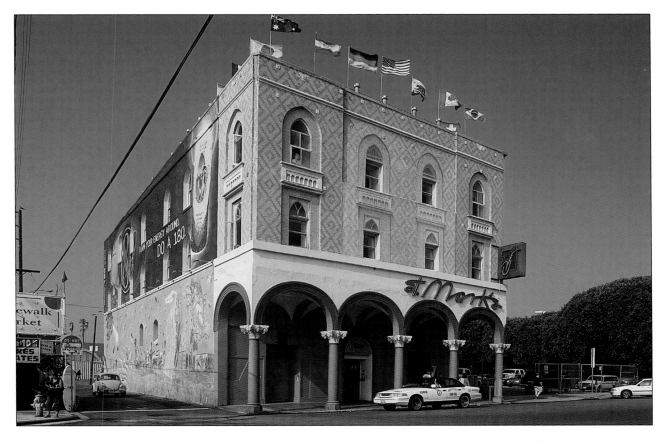

The Depression took its toll on Venice, and eventually St. Mark's Hotel was abandoned. By the 1970s, many of the beautiful Italianate buildings had crumbled or were demolished, and the arched windows were filled in or modernized. Since then, artists and beach bums have enjoyed the sunny climate of Venice. In the 1990s, however, architects and New Agers rediscovered this historical resort and have been carefully restoring the area. St. Mark's is now the Venice Beach Hotel, a youth hostel and beach cantina.

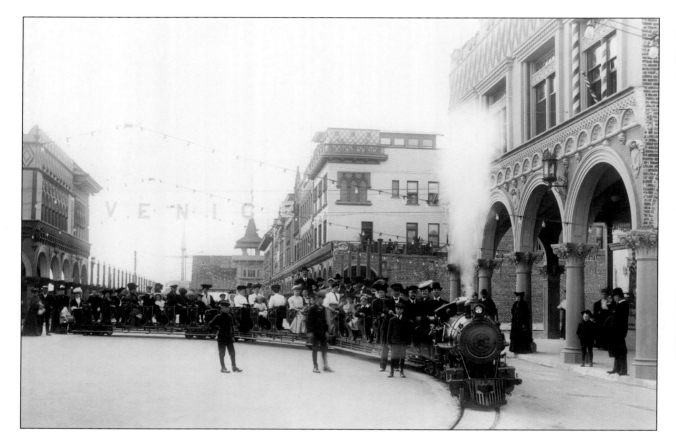

When this photo was taken in 1910, Windward Avenue was the hub of excitement at Venice Beach. Abbot Kinney had introduced Coney Island-style roller coasters, dance halls, the Venice Plunge (a pseudo-Arabian bathhouse), and camel rides at the Streets of Cairo attraction. Miniature train rides, arcades, and carnival shows were among the attractions that people came to Venice to enjoy—and some preferred a simple stroll through the colonnades in the sea air and sunshine.

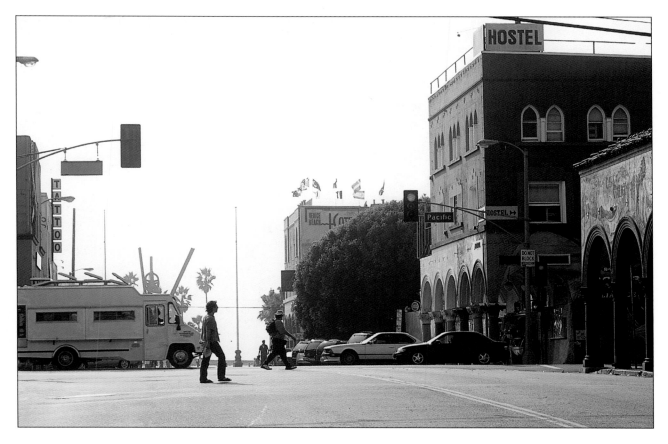

At the ocean, Windward Avenue is now lined with the remnants
of beautiful buildings. The local historical society has been saving
and renovating the old structures as fast as it can. Today craft stores,
secondhand shops, boutiques, and small art galleries nestle in with taco
stands, juice bars, and coffee shops. Musicians, street performers, and
skateboarders abound. The annual Hare Krishna parade is held here,
and this colorful area was featured in *L.A. Story* and *American History X*.

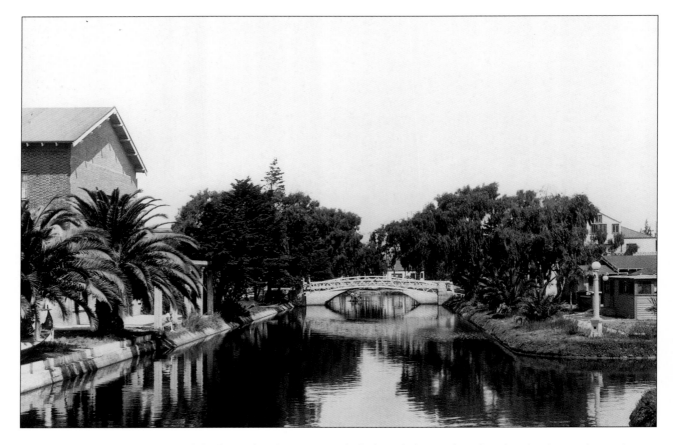

In 1904, when Abbot Kinney (who made his fortune from Sweet Caporal Cigarettes) was building Venice, he envisioned a fleet of Venetian gondoliers poling their way through interconnecting canals. Sixteen miles of canals were dug from salt marshes, bungalows were built alongside them, and people took to their boats and enjoyed water carnivals. After problems with poor drainage in 1929, the majority of the canals were filled in and converted to roads.

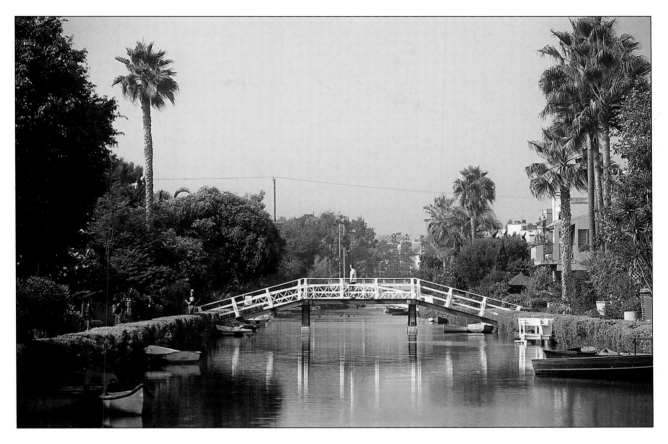

Artists and hippies loved living here, and Jim Morrison of The Doors called the area home during the 1960s. The Grand Canal, at Windward and Main, where all the waterways connected, has long been paved over. In the 1980s, as real estate prices soared, the bohemian canal-dwellers were replaced by the wealthy. In 1994, the city finally refurbished the six remaining canals. Still a magnet for artists and filmmakers, the canals run through a picturesque and tranquil neighborhood.

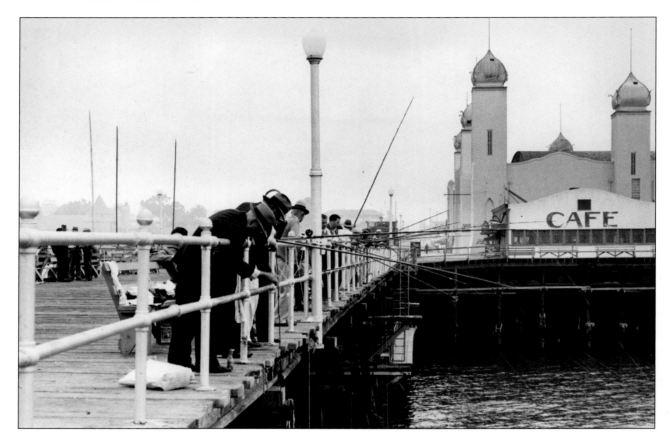

Rebuilt several times since its construction in 1874, Santa Monica Pier is one of the few remaining landmarks of turn-of-the-century Los Angeles. Shoo-Fly Landing, its original name, had a hippodrome with a carousel, amusement park, and a wonderful ballroom called La Monica, scene of many 1920s dance marathons. There was good fishing at the end of the pier, where water taxis were rented to take people to offshore gambling barges. Of all the local piers, Santa Monica was the best and most popular.

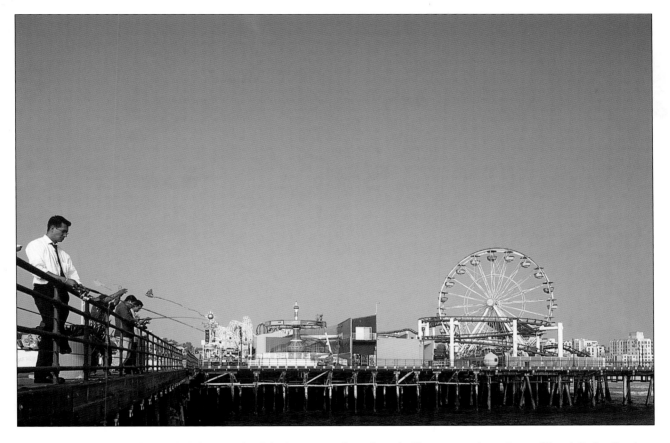

By the late 1960s, much of this area had disappeared and the Santa Monica Pier was in trouble. In 1983, terrible rainstorms washed away part of the pier. Today the Santa Monica Pier has been carefully restored, and although the La Monica Ballroom is gone, the 1916 hippodrome building is restored, now home of Rusty's Surfing Ranch, with vintage surfing memorabilia. The amusement park has the world's first solar-powered Ferris wheel—and there's always fishing at the end of the pier.

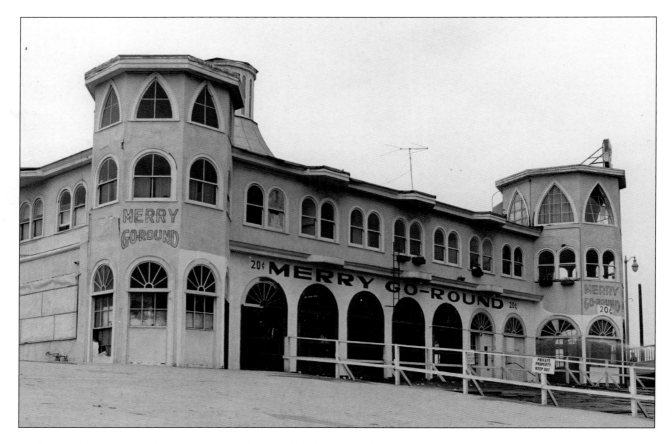

On the Santa Monica Pier in 1922, a merry-go-round was installed that was to become a classic. The wooden animals that the children rode were hand-carved by a New York furniture maker, Charles Looff. Looff later built his own pier and more rides, but this merry-go-round was special, and it was eventually listed on the National Register of Historic Places. Housed in the 1916-built hippodrome building, the carousel was refurbished in 1947.

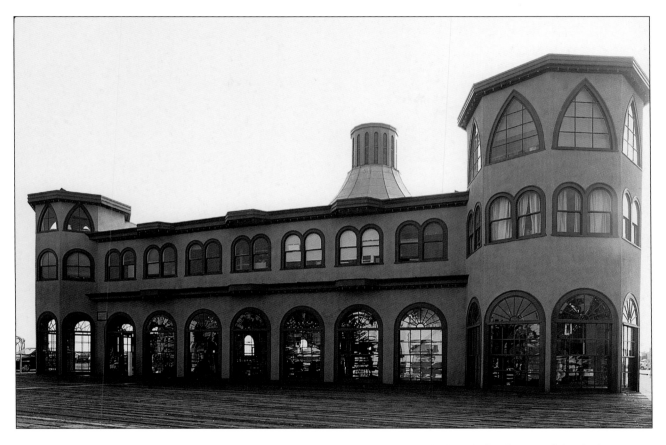

When the Santa Monica Pier fell into disrepair in the 1970s, the city closed the merry-go-round and it was threatened with destruction. Luckily, many people had fond memories of it from their childhoods—others from seeing it in *The Sting* with Robert Redford and Paul Newman or from *Columbo* and other shows—and they fought to preserve it. In 1981, it was lovingly rescued and restored. Having recently undergone another face-lift, it is again open to the public, as popular as ever and available for party rentals.

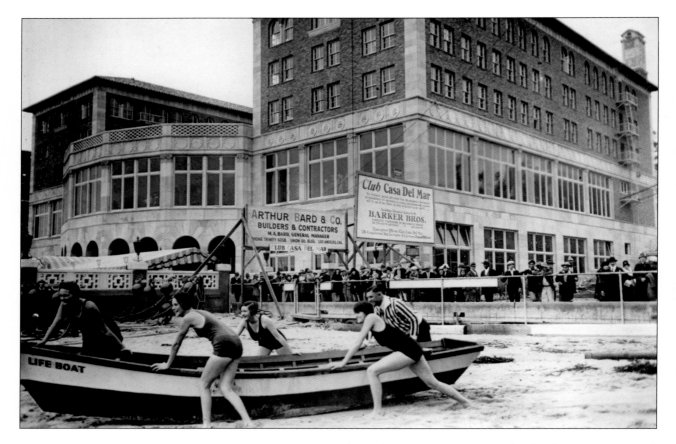

Casa Del Mar opened in 1926 as a beach club in Santa Monica. Designed by Charles F. Plummer, the Renaissance revival style of the club, hand-painted ceilings, and bronze statuary made it the classiest building in Santa Monica. The social elite and Hollywood celebrities flocked to the hotel. During World War II, Casa Del Mar became a military hotel, reverting to a public hotel when the war was over. In the 1960s, the building housed the controversial Synanon drug rehab program.

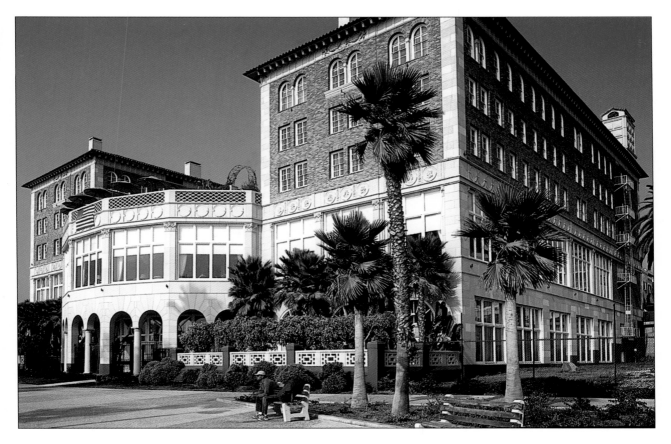

From 1978 until 1997, the Pritikin Longevity Center was headquartered here. Then it was bought by the Leading Hotels of the World group. In October 1999, the Hotel Casa Del Mar opened, seventy-five years after its debut. Over $60 million was spent on the restoration of this historic landmark, giving it a 1920s feel. The grand ballroom has Venetian glass chandeliers, the gardens are landscaped, and a new health club and business center have been added.

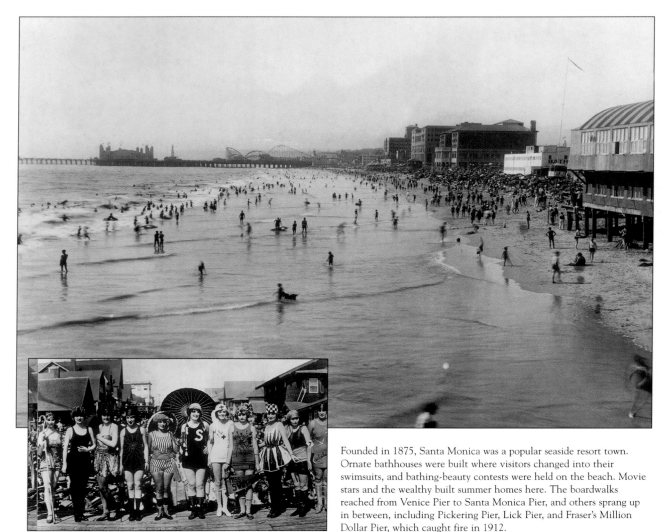

Founded in 1875, Santa Monica was a popular seaside resort town. Ornate bathhouses were built where visitors changed into their swimsuits, and bathing-beauty contests were held on the beach. Movie stars and the wealthy built summer homes here. The boardwalks reached from Venice Pier to Santa Monica Pier, and others sprang up in between, including Pickering Pier, Lick Pier, and Fraser's Million Dollar Pier, which caught fire in 1912.

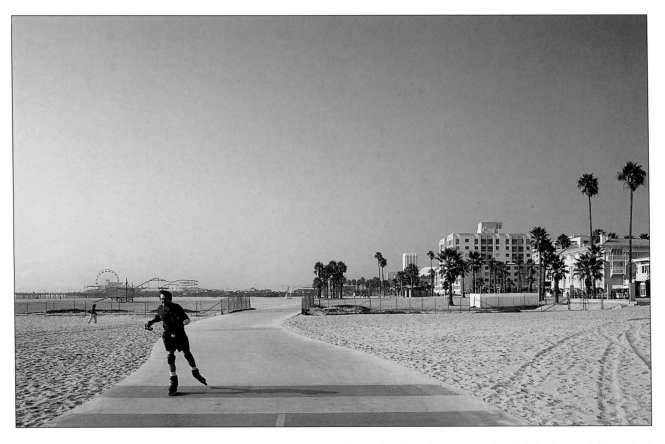

In the 1970s, the remaining bathhouses were demolished. The fancy oceanside homes remain, although some were lost in the floods of 1983. As the years passed, many of the piers crumbled or, because they were all wooden, burned down. Only the Santa Monica Pier survives, along with its legendary nine-story Pacific Wheel, the only Ferris wheel in California situated over the ocean. Today, rollerbladers and skateboarders fill the boardwalk, and surfers and swimmers enjoy the waves and breathtaking sunsets.

INDEX